André Masson: Line unleashed

A RETROSPECTIVE EXHIBITION OF DRAWINGS
AT THE HAYWARD GALLERY, LONDON

The South Bank Centre 1987

Exhibition dates: 7 July to 27 September 1987

Copyright © 1987 The South Bank Centre and authors
© DACS 1987
Exhibition selected by David Sylvester
Catalogue edited and exhibition installed
by David Sylvester and Joanna Drew
Exhibition setting designed by Paul Williams
Catalogue designed by Simon Rendall

Printed and bound in Great Britain by Westerham Press

ISBN 1 85332 002 1

The South Bank Centre is a constituent part of the Arts Council of Great Britain and is now
responsible for the Hayward Gallery and the Arts Council's exhibitions service.

A list of Arts Council publications including all exhibition catalogues in print can be obtained
from the Publications Officer, South Bank Centre, Royal Festival Hall, London SE1

Cover illustration: Erotic Land 1943 (no 90)
Musée Nationale d'Art Moderne, Centre Georges Pompidou, Paris

Acknowledgements

The exhibition's title is derived from that of the essay by Michel Leiris which is published here in a new translation.

In choosing the works, the selector, David Sylvester, has had the confidence of the artist and the whole-hearted collaboration of his family. We are particularly indebted to Diego and Guite Masson.

We are also much indebted for advice, information and assistance to M. Ghislain Uhry and to MM. Maurice Jardot and Bernard Liermans of the Galerie Louise Leiris. Our thanks are also due to Servane Zanotti and Sarah Whitfield.

The biographical note is drawn mainly from the full and excellent chronology by Frances Beatty in the catalogue of the Masson retrospective organised by the Museum of Modern Art, New York in 1976.

Finally we thank the lenders, especially the Musée National d'Art Moderne, Centre Georges Pompidou, Paris.

Joanna Drew
Director, Hayward Gallery

CONTENTS

Anatomy of this exhibition

'The drama of nature, the cruelty in life, the ferocity of the sexual instinct, such are the recurrent themes of Masson's art . . . I believe that Masson is the great tragic artist of our period.' Thus Douglas Cooper, in the catalogue of an exhibition, *Designs for Hamlet, Book Illustrations, Lithographs by André Masson,* presented by the Arts Council of Great Britain in 1947. Apart from that showing of a selection of marginal work, there has been no one-man exhibition in any British public gallery till now, in Masson's ninety-second year.

In making the selection for this retrospective of Masson's drawings, there were three factors which determined the choice of the sources for loans. One was a resolve not to select works on the basis of a photograph or of memory, since neither can be trusted in regard to an art where the quality of the marks on the surface matters more than everything else put together. The second was that the budget was not unlimited. The third was the presence of large and strong holdings of available material in a nearby place, Paris – in the collection of the Musée National d'Art Moderne, in the stock of the Galerie Louise Leiris, in the possession of some well-disposed private collectors, and above all in the hands of the artist and his family. The artist's studio did not only include numerous well-known pieces which he had insisted on retaining but numerous portfolios filled with countless sheets and scraps, almost all of them unsigned, which had never been shown or reproduced, which I was generously allowed to examine and which seemed to me as I did so to contain many hidden gems. The conviction therefore grew that it was not necessary to look beyond Paris for loans, even though that meant the omission from a retrospective of a number of famous examples scattered around the world. But in any case, most of those famous pieces are highly finished drawings – 'exhibition drawings' – and I wanted this selection to emphasise the more spontaneous kinds of drawing, because I think that what makes Masson a great draughtsman is not his invention as an image-maker but the vitality and sensuality of his line.

The original intention was to make the exhibition one of 'works on paper', so that it could include water-colours and pastels, as it is always nice for an exhibition to have plenty of colour. But it soon became clear that water-colours and pastels which were solidly coloured and thus substantial *pictures* were going to make the works that were strictly drawings look like ghosts, and as these were already very varied it seemed foolish to sell them short. Consequently, as the selection evolved, there was an elimination of very nearly all these water-colours and pastels which came into the category of pictures, as against those which introduced a touch of colour as an exhancement to drawing.

Again in the interests of the overall look of the show, a few of the works in the catalogue list will probably be left out in the course of installation. The installation will distinguish between the more finished and the more sketchy drawings by showing the former on the walls, the latter usually in desk-cases, unframed, with related examples situated as near to one another as is feasible. The sequence in which the various groups of works will be arranged has not been fixed in advance. What is sure is that the point of departure for the arrangement will be a partition into sections each devoted to one of five types of drawing – iconographic rather than stylistic types – all of which have been exemplified during several decades of Masson's career; it remains to be seen how far this will work in reality. In any event, the plates in the catalogue, which illustrate about a quarter of the works, are divided into batches representing those types. It is a rough-and-ready division, not at all an attempt to provide a watertight classification, and not covering everything, but serving, I hope, to demonstrate the coming and going and interweaving of certain more-or-less perennial preoccupations.

The first type (plates 1 - 6) consists of figure-compositions of a thoroughly traditional kind. They are traditional in that they depict the human figure with no more ambiguity than do the figure-compositions of Signorelli or Rubens or Poussin or Boucher; the figures may be distorted by the linear rhythms which convey their drama, but not so that they become metaphors for other kinds of being, as they do in so much twentieth-century art. These figure-compositions are also traditional in

harping on sex and violence. The other great traditional subject of European figure-composition, religious ecstacy, does not come within Masson's compass, but it could be said that sexual ecstacy attains a pitch of fervour in his art where it becomes as interchangeable with religious ecstasy as it does in Bernini's St Theresa.

The works in this type mainly fall within three main groups. The first, dating from 1921 - 22 (plates 1 - 2), are line-and-wash drawings of lesbian orgies which seem intensely influenced by Rodin (but are superior to Rodin drawings in that they suggest the plenitude of the body's volumes without sacrificing the flatness of the pictorial surface). Dating from the early 1930s, the next group (plates 3 - 4) in which emphatically legato lines like those of the first group are now counterpointed by an insistent staccato, are depictions of massacres. The third group is represented here (plate 6) by one of the pages from a sketchbook, probably dating from the early '50s, of line-drawings in pencil inspired by Japanese erotic prints, by Utamaro and others.

The second type (plates 7 - 14) consists of automatic drawings – or so-called automatic drawings, a reservation that has to be made in the light of the perennial question as to how far a highly trained and deeply cultivated artist can achieve a drawing that truly conforms to the surrealist definition of automatism. These drawings, mostly dating from the mid-1920s, are widely regarded as being Masson's key contribution to the history of biomorphic surrealism and of its great offshoot, the branch of abstract expressionism to which Gorky and Pollock belong. Later examples include a series realised in the mid-1950s of whirling linear improvisations using sand (plate 14).

I take this second type of Masson drawing to incorporate his post-cubist drawings of 1923 - 24 (plate 7), despite the fact that these present a specific image whereas the automatic drawings begin with the free movement of the hand on the paper, a movement used as a means of generating forms which may become images. I nevertheless incorporate the post-cubist drawings into the type because they are so clearly its point of departure. It is true that the character of the line in the early automatic drawings tends to resemble that of the orgiastic figure-compositions. But conceptually they come out of cubism, especially the cubism of Juan Gris, who

befriended the young Masson at about the time of writing his famous statement to the effect that abstract forms were not what he arrived at but what he started from. 'I proceed from the general to the particular, by which I mean that I start with an abstraction in order to arrive at a true fact . . . Cézanne turns a bottle into a cylinder . . . I make a bottle – a particular bottle – out of a cylinder. Cézanne tends towards architecture, I tend away from it'. By the same token, Masson's post-cubist drawings begin with certain abstract forms and evolve images out of them; his 'automatic' drawings virtually do the same but with more freedom, more exploration, more violence. And, indeed, the affinity is not merely conceptual but visual: plates 8 and 10 are like a cross between the clearly cubist plate 7 and the clearly 'automatic' plates 11 and 12. The only real difference between Masson's post-cubist drawings and his 'automatic' drawings is that the former are Apollonian, the latter Dionysian. That is why it was possible for 'automatic' drawings to generate, as they palpably did, many of the post-cubist paintings of 1924 - 25 as well as of the sand paintings of 1926 - 27.

The third type (plates 15 - 20) relates to the opposite wing of the surrealist movement, the Chirico-Magritte-Dali wing, but is not so much specifically surrealist as an extension of the long tradition of fantastic art – Bosch, Arcimboldo, de Momper, Bracelli, Grandville and so on. The realisation tends to be tight and detailed, giving an illusion of solidity to forms. And also a sense of stability, for, while these works often illustrate a metamorphosis, it is a metamorphosis already consummated; they do not give that sense of the actuality of the process of metamorphosis which is to be found in the ambiguous forms of our fifth type of Masson drawing. Most of the drawings of this third type were executed in the late 1930s and early '40s, but they went on appearing in later years: plate 20 shows one dating from the onset of the '70s. These later examples generally dispense with the precise realisation of their predecessors, are much more free and calligraphic in execution – but still static, not fluid, as images.

The fourth type (plates 21 - 26) consists of landscapes, particular landscapes in Spain, in Martinique, in France. They are always redolent of the locale, whether they

tend towards naturalism or towards calligraphy – they generally lie somewhere in between. The examples in the show stretch from the 1920s to the 1950s. Varying allegiances to European masters have affected them at different times; Chinese painting seems to have been a rather abiding source of inspiration.

The fifth and final type (plates 27 - 34 and cover) comprises landscapes that are figures and figures that are landscapes. They first appear in the mid-1930s and go on doing so, almost uninterruptedly, until the 1970s. Several bear the title *Terre érotique*, and these and many of the others are brimming with images of sexual organs and erogenous zones which at the same time are images of plants and of the undulations of the surface of the earth and of undulations and cascades of water. Thus certain stylisations of the genitalia which are clearly borrowed from the Japanese prints alluded to above do not only occur in the erotic scenes (plate 6) but also among the sketches of waterfalls (plate 24) as well as in several drawings of the present type (e.g., plates 28 and 34). That is to say, the drawings of this type subsume characteristics of the previous types – of all those types: the lechery of the orgies and the violence of the massacres, the method of automatism and its charge, the imagery of the fantastic drawings; and landscapes is what they are, only, transfigured.

These drawings, perhaps the most intense expression in Masson's work of the drift of his imagination, present a Heraclitean flux where everything is turning into everything and tenderness and violence are forever melting into one another, a jungle of irrepressible growth and irresistible annihilation and new growth. 'A God-intoxicated man' was how Novalis described Spinoza; Masson is an earthier inebriate, intoxicated by nature's sap and nature's savour. The savour of these drawings can be voluptuous, menacing, psychedelic, edgy. And Rabelaisian, as where, against the background of a mammary mountain range, the main action is a proudly gross and hairy coupling while to one side, as sub-plot, a naked man is seen from behind pushing against a looming pair of boulders shaped like a woman's buttocks, straining with all his might to open them up and get back in.

'At the beginning of all things is the underground world of unsatisfied instinct', wrote Masson in the Prologue to his *Anatomy of my Universe*.

DAVID SYLVESTER

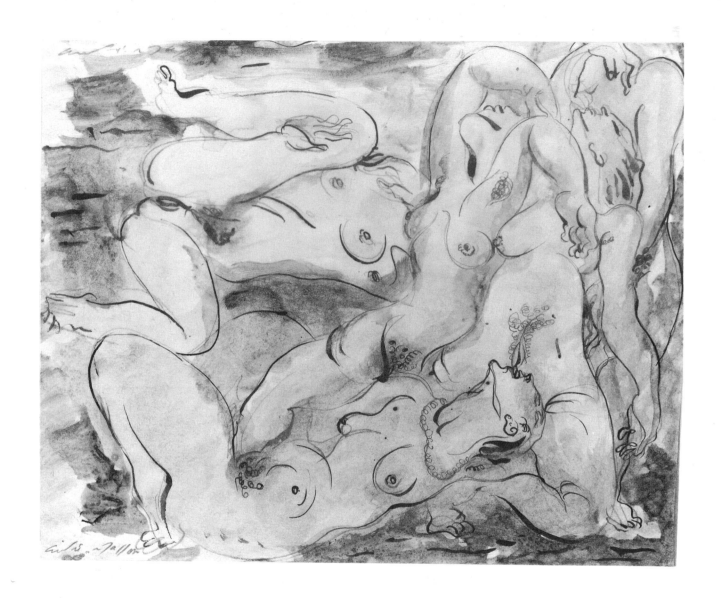

PLATE I · 2

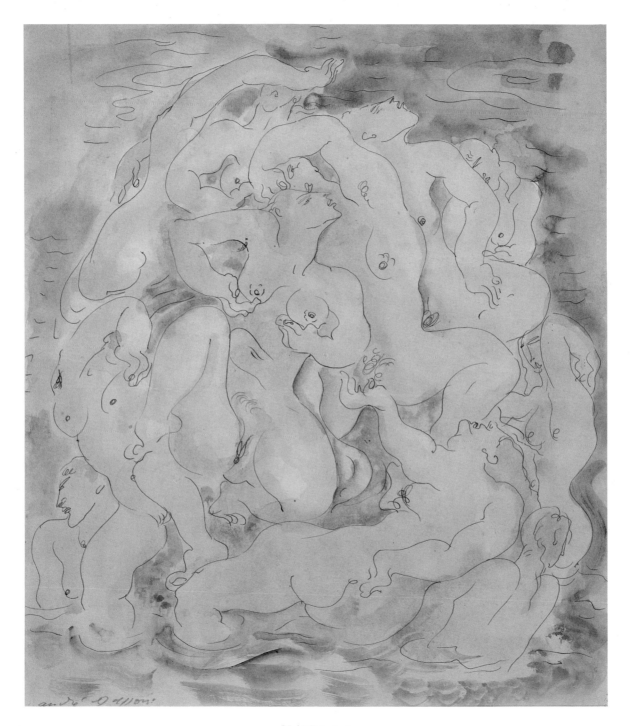

PLATE 2 · *3*

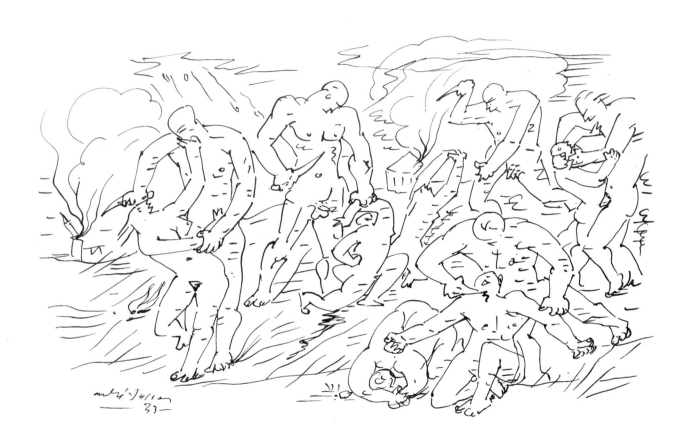

PLATE 3 · *43*

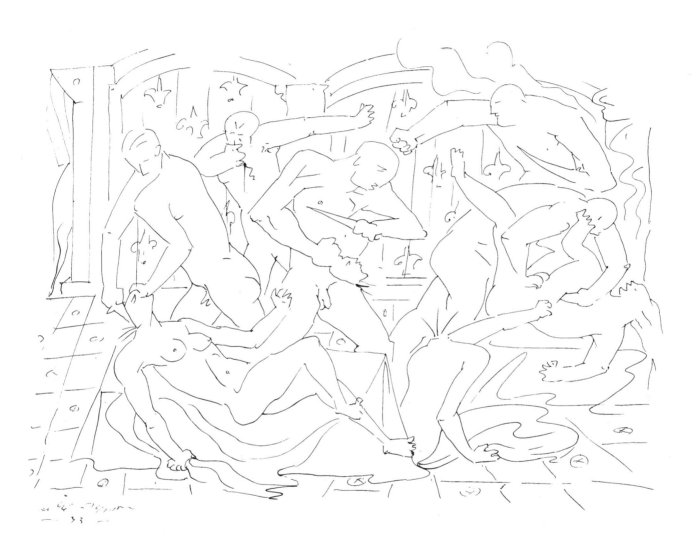

PLATE 4 · 39

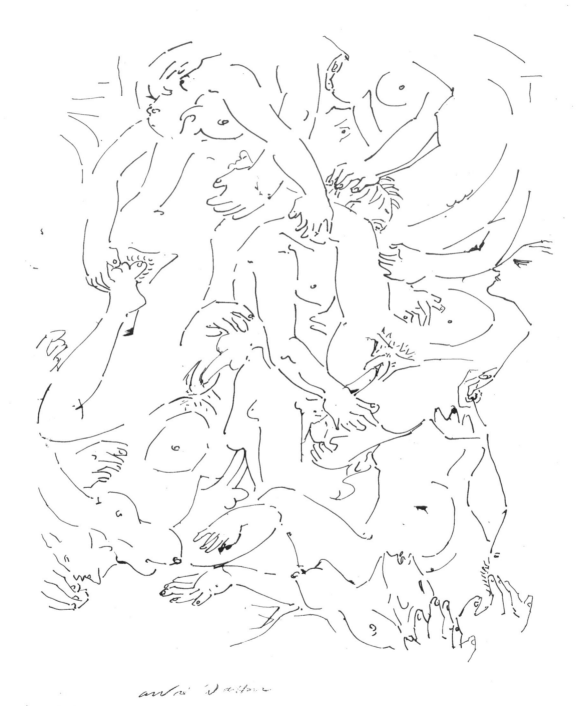

andré Masson

Justine. *Rodin et les pensionnaires*

PLATE 5 · 30

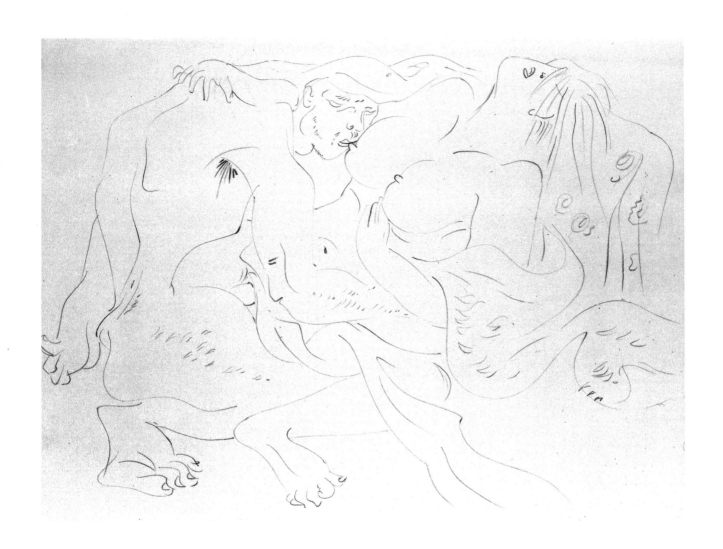

PLATE 6 · *125*

Movement and metamorphosis

Masson's work is so varied and extensive that no single exhibition has yet shown all of its aspects. Critical interest has tended to focus on those that connect with a mainstream in the history of twentieth-century art: his relationship with Surrealism above all, and, more tangentially, with Abstract Expressionism. However, to seek his identity through a movement or a style would give it only an illusory coherence, not just because of Masson's own restlessness in matters of style, but because of the nature of the ideas that underpin his attitude. He himself wrote:

> 'Against those who proclaim their constancy in the matter of surrealist painting, I assert more than ever the virtue of change. To act is not to conserve. To act is to have the power to contradict oneself, to move, to be that great traveller of the Taoist parable: that great traveller who doesn't know where he is going. "The combat of nature and spirit is the law of the world", as Hegel said . . . That's true for all times. Our concern is even more charged in its particularity. It is that painting has not now, as it had in the past, a true destination, it no longer finds " its victory and its rest" in answering to the spiritual needs of people. It lives off itself. The brief pleasure it can still give should not delude us: it no longer has any effective necessity. The painter is thus forced to invent his own dialectic and carry it at the heart of his work.' [1]

No-one has put more clearly the nature of Masson's 'own dialectic' than his friend the poet and enthnographer Michel Leiris when speaking of:

> 'the capacity he has always had – and retains at over eighty – to give himself (and to give) sumptuous celebrations, not for the sake of a vain need for amusement but from a desire to experience the transfiguration of his radically pessimistic idea of the world's advance.' [2]

This conflict, between the 'radical pessimism' Leiris names, and a sense of exuberance and exaltation – what Bataille called 'ravissement hors de soi' – lies at the heart of Masson's dynamic vision: death and life, violence and eroticism. The particular

character of Masson's apprehension of the 'combat of nature and spirit', and its genealogy, shares a great deal with Georges Bataille, and this will be the subject of the second part of this essay.

Masson was ambivalent about the *métier* of the painter, and many of his essential relationships were with poets and writers within and outside the surrealist movement. Pierre Reverdy, the poet who is also associated with Cubism, 'recognised me as a painter,' Masson recalled, 'but found in me a sensibility ("torn" he used to say) closer to that of poets than to that of my brother-artists in which, perhaps, he was not altogether wrong.' [3] This poet's sensibility certainly helped endear him to André Breton, Surrealism's founder, to whom he was closer for a time than any of the other painters drawn into its seductive orbit, and who expressly and favourably contrasted Masson's 'chemistry of the intellect' with Miró's 'single desire to give himself up to painting alone.' [4] Visual gratification was not, in itself, enough. Georges Limbour, whose poems *Soleils Bas* Masson illustrated in 1924, described Masson as a 'hero of the imagination.' But Masson did not in fact work only from the imagination; Limbour in the same text describes the experience of sitting for him as model:

'He wants to take some sketches after nature, so he sits me down, quite comfortably, then with feverish haste fastens a large sheet of paper on his easel. He runs towards his drawing pins, his charcoal, with hurried movements as though there was no time to lose before the universe – myself and the light – should vanish. An intense fire has already taken possession of him: the charcoal screeches on the paper. Is he drawing? He seems rather, from the sounds, as though he is energetically tearing a face with pencil blows . . .' [5]

The horrific experience of the first World War, although not directly represented by Masson at the time, fed into the themes of violence and death in his work. He spent two years in the trenches, followed by two in hospital with a serious chest wound. He returned to painting in 1919, but it was only at the end of 1922 that an agreement with Kahnweiler, Picasso and Braque's pre-war dealer, and Juan Gris's friend and dealer, enabled him to give up his night job at the *Journal officiel* and for the first time since he was a student to paint seriously. In the winter of 1921-2 he rented a

studio in the rue Blomet; there were two artists' studios next to a cheap hotel and a primitive but extremely noisy factory, and, by chance, the other was rented at the same moment by Joan Miró. 45 rue Blomet became the meeting place of a group who were to remain lifelong friends, including Roland Tual, Georges Limbour, Michel Leiris, Antonin Artaud and Georges Bataille. Masson described the atmosphere:

> 'This camaraderie – companionship might be more exact – had nothing typically "intellectual" about it; to speak and feel together, eat communally, work with the same impulse, and *dance* (like Nietzsche we could not have got on with a god who didn't dance). Above all to be and remain uncommitted (vacant) took the place for us of morality. . . . Nietzsche, Sade, Dostoevsky, to salute them first of all . . . but here I must point out a difference with most of our contemporaries: our choice was not guided by literary interest or philosophical pretexts alone. Those three named above, tutelary, were for us, before anything else, the great shatterers of conventional horizons.' [6]

Both Miró and Masson had an ambiguous relationship with Cubism, which was still, in post-war Paris, the most advanced style, although it had developed and diffused in a number of directions. Opposed to Cubism, and to the call for order and progress that was the dominant mood in defence against the instability and disillusionment that followed the war, was the irreverent polemic of Dada, which had a loud voice but relatively few adherents, although these did include the newest poets and writers like Louis Aragon and André Breton. Their review, *Littérature*, known to both Miró and Masson, was at the 'extreme point', as Masson put it, of the avant-garde. Since 1922, however, *Littérature* had left Dada behind; its new series was marked by an open, questing spirit, which rejected the pursuit of literature for its own sake, and sought in the most provocative ways to blur the conventional boundaries between life and art. There was much in common between rue Blomet and the *Littérature* group – kernel of what was to be orthodox Surrealism, centred on Breton's apartment at 42 rue Fontaine – although the only person to move frequently between the two was Georges Limbour, who showed a marked scepticism at the

Littérature group's temporary obsession with the hypnotic trance, borrowed from the mediums, as the key to 'psychic automatism.' It was Limbour who read to his rue Blomet friends the Elizabethan and Jacobean tragedians, and who sought to preserve the miraculous peace of the rue Blomet against the inevitable encounter with Breton. They met in 1924, and discovered their shared dislike of the pursuit of literature as such. Rimbaud was the 'exemplary poet above all others', and they were on common ground in talking of Lautréamont, of Pierre Reverdy, of Raymond Roussel, but a sharp difference of opinion arose over Nietzsche and Dostoevsky. 'Everything I hate most', Breton said to Masson. Such disagreements signal, although do not explain, underlying conflicts between Masson and the Surrealists. Those of the rue Blomet never imagined formalising themselves into a 'movement'. They valued their independence, and it was certainly the orthodoxy of the Surrealists and a certain prejudice and conformity in sexual issues, which contributed to the disaffection of Masson and Leiris by the end of the Twenties. Then, Masson moved in anarchist circles, and though he sympathised with the revolutionary ambitions of the Surrealists, it was from a very different point of view than that of the orthodox Marxist.[7] Most importantly of all, the 'radical pessimism' Leiris described above was in conflict with the essential optimism of Surrealism. It was this that made Masson a natural ally of Bataille, who never joined Surrealism.[8]

Masson's involvement with Surrealism did not disturb the friendships and collaborations with the rue Blomet group; indeed the first manifestations of the movement were very much a result of an alliance between the two groups. The character of the first issues of *La Révolution Surréaliste* owes a great deal to Artaud, and to, especially, the automatic drawings of André Masson, but the surrealist context of these drawings needs to be examined more closely.

Mason began the automatic drawings sometime in the winter of 1923 - 24 – before, in other words, he met Breton, and shortly after he had begun to develop his highly idiosyncratic cubist manner. His drawings were both a continuation of and a rupture with his Cubism. He later wrote: 'These drawings opened a world for me. A little that of the mediums. More bluntly, that of analogy, a term which mentally imposed

itself but which perhaps I wanted to keep secret. It was not in the vocabulary of the time, where the cubists' word plastic metaphor still had authority.'[9]

Four points might be made before examining Masson's unorthodox Cubism more closely. Firstly, it is not in fact surprising that Masson should have had recourse to automatism before the publication of Breton's first *Surrealist Manifesto* in the autumn of 1924, where 'pure psychic automatism' was made the key to Surrealism. Automatism, which already had a long history in the contexts of both psychology and spiritualism,[10] was familiar to the *Littérature* circle and its readers. In 1919 Breton and Soupault had published in that review their automatic texts '*Les Champs Magnétiques*'; the new, post-Dada series of *Littérature* (1922-24) revived the idea, and in 1922 Breton published 'Entrée des Médiums', in which the results of the hypnotic trance, borrowed from the mediums, including records of 'conversations' and scrappy drawings, were published as examples of 'psychic automatism', to which he already gives the name 'surrealism'. Although little reference to the mediums remained in the first *Manifesto*, where Freud's discoveries are given pride of place in relation both to the surrealist interest in dream and in automatism, it was not until 1933 that Breton published a detailed study of mediums' art, 'Le Message Automatique', and clearly distinguished between the mediums' stance and their own, in that the former believed that what they wrote or drew constituted messages from 'beyond.' Masson, significantly, referred to mediums and to trance in his own accounts of automatism.

Secondly, there was no *given* mode of visual expression at this early moment in Surrealism, and, indeed, what form this might take underwent considerable debate.

Thirdly, Cubism itself should not be seen in a simple oppositional relation to Surrealism – not, at least, that of Picasso. Breton always stressed his importance for Surrealism, recognising that the cubist disruption and dislocation of objects, and of the representation of space, opened a path to their imaginative and irrational re-working. Picasso's *Girl with a Hoop* was among the few reproductions in *Littérature,* and Masson's *The Four Elements,* which Breton purchased from Masson's first one-man exhibition at the Galerie Simon (February-March 1924), lies, however oddly, within a cubist tradition. Finally, the major impetus for Masson's automatic

drawings came, he has said, from Paul Klee (who had, interestingly, been in contact with Zürich Dada). Klee's drawings of c.1919 (of which Masson saw reproductions), were made in a manner similar to automatism and spring from his idea of rendering visible rather than reproducing the visible. 'Before the process of becoming,' Klee wrote, 'there is always movement.' [11] Line is not inevitable contour, but can become expressive in an infinity of ways: undulating, breaking, losing itself; then, turning into objects interlaced and interwoven.' From this Masson began to explore line itself, moving away from the complex dialogue with static objects of analytical Cubism towards a more dynamic, unstable world.

To return now, briefly, to Masson's Cubism. The subjects of his cubist paintings – still-life, gamblers, eaters, drinkers (the domestic life of the rue Blomet), forests, were still those of the Derain-influenced pictures of the previous year. Although the restricted colours (brown, green, ochre, grey) recall those of analytical Cubism, and the surface has in parts a broken faceted appearance, with occasional juxtaposition of different viewpoints of objects revealing the influence of Juan Gris, the forms of human figures, birds, fishes are not broken up but remain whole, and contract and swell in curviliner shapes. Objects are invested with expressive or symbolic force: the knife which might in a cubist still-life lie beside pipe and bottle now points at the eye of a seated man, or hovers above the severed head in *The Man in the Tower*.

The forests were from the start imbued with a poetic expressiveness; initially inspired by the forests of Clamart, they quickly lose the character of nature observed, but, far from moving under the influence of Cubism towards a greater abstraction or pictorial autonomy, take on an imaginary quality: 'a feeling that was recognised as panic, or legendary, rather than animated by the habitual reference to a known site.' [12] With the introduction of tombs, and the sea, the romantic references become stronger – to, for instance, Chateaubriand's *Memoirs d'Outretombe*. The dramatic angle of the scene in *Tomb by the Edge of the Sea*, with the rolling waves apparently heaping up above the tomb, recalls the great invocation in Lautréamont's *Chants de Maldoror* to the ocean, unsoundable by man and infinitely grander and more terrible.[13]

One of the objects that appears most persistently in Masson's paintings and

drawings, and one of the most loaded with associations, is the pomegranate. It is present in still-lifes of 1922, and subsequently in connection with both male and female figures. It is for Masson, as Carolyn Lanchner says, 'at the same time symbol of life and death.' [14] It appears whole but with an incision like a wound at the side, revealing the red flesh within, or split with seeds and membranes visible. For Masson it recalled the head of a dead soldier, but also had the contrary association with blood and fecundity. In *Open Pomegranate* it stands as the genital source of life, from it springing the female torso.

Some recent developments in post-war Cubism had developed the daring games of Picasso and Braque into relatively anodyne formal rhythms, but Masson was beginning to explore a poetic analogy, as when, in *Man with an Orange*, he multiplies the orange into suns spinning away into infinity, and also, through the use of transparent and dissolving forms, the interpenetration of figures and objects.

In the painting bought by Breton, *The Four Elements,* the bird, fish, candle, flame and ball/globe symbolise the substances of which ancient and mediaeval philosophers believed all material bodies were compounded: air, water, fire and earth. A female figure vanishes into a tomb, and Masson introduces architectural elements which, over the next two years, fuelled by a fascination for Piranesi, become important motifs.[15] The fragmentary architecture, entablatures, steps, arches, pedestals, is highly ambiguous in terms of space, direction and scale, sometimes opening to a double reading, sometimes merging with more abstract cubist planes.

One of the first automatic drawings, known as *Study for Nudes in Architecture,* although not strictly a study, in that it relates to more than one painting, reveals the ambivalent relationship between this kind of drawing and the paintings. The silhouette of a man, closely related to that of *The Sleeper,* framed in architecture, cocoons in his arms (where a still-life might have been) a loose web of lines, in which a female torso(s) is visible, tiny in scale and clearly *dreamt*. In subsequent paintings loose, flowing lines are introduced within and break the cubist framework, but at the same time there are a number of 'cubist' elements in the automatic drawings themselves. These automatic drawings were not, then, in any simple sense, a search

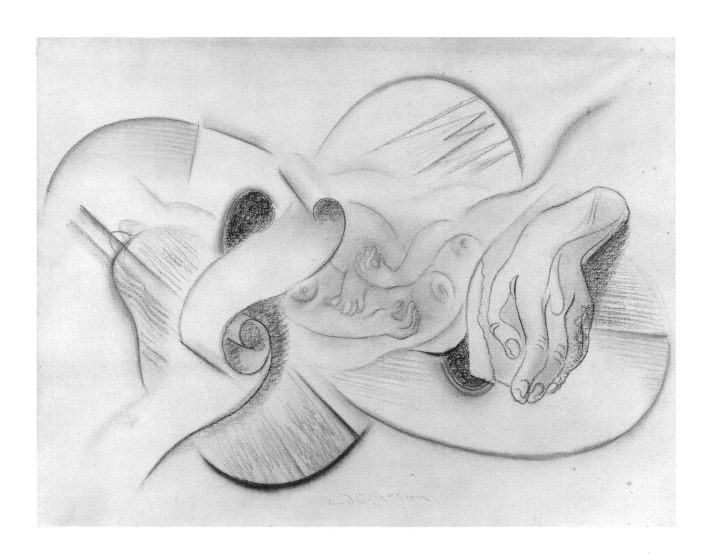

PLATE 7 · *10*

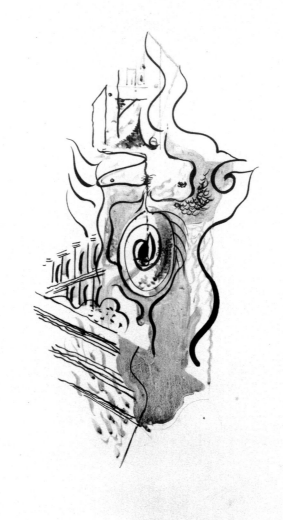

PLATE 8 · *14*

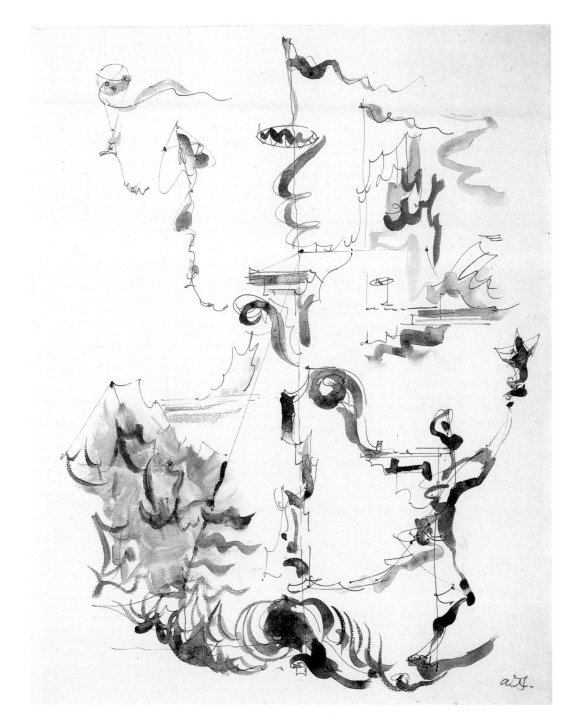

PLATE 9 · 28

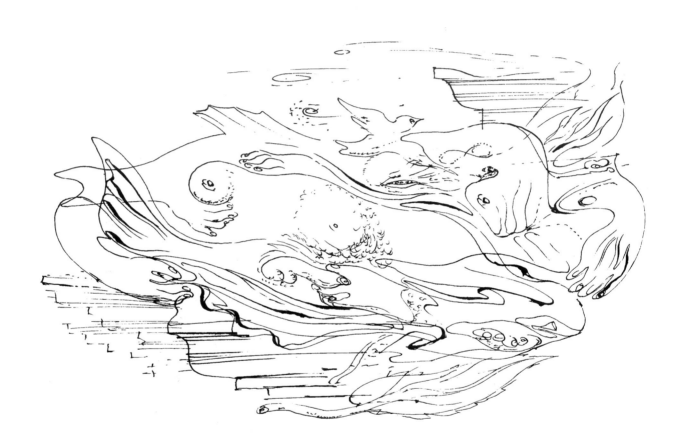

PLATE 10 · *II*

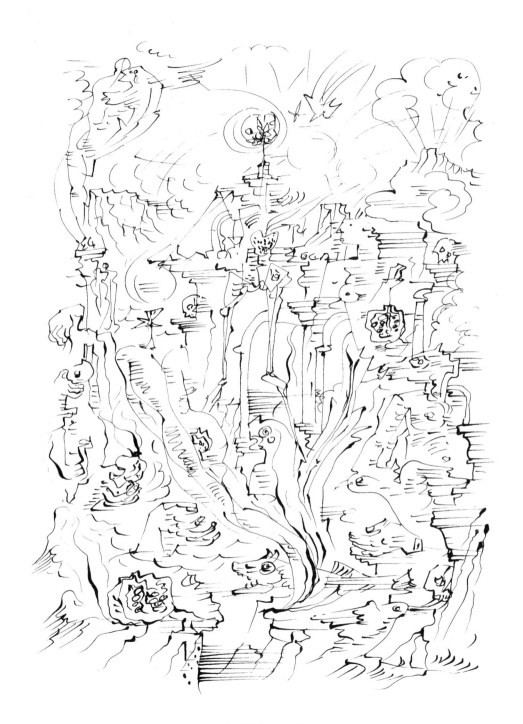

PLATE II · *19*

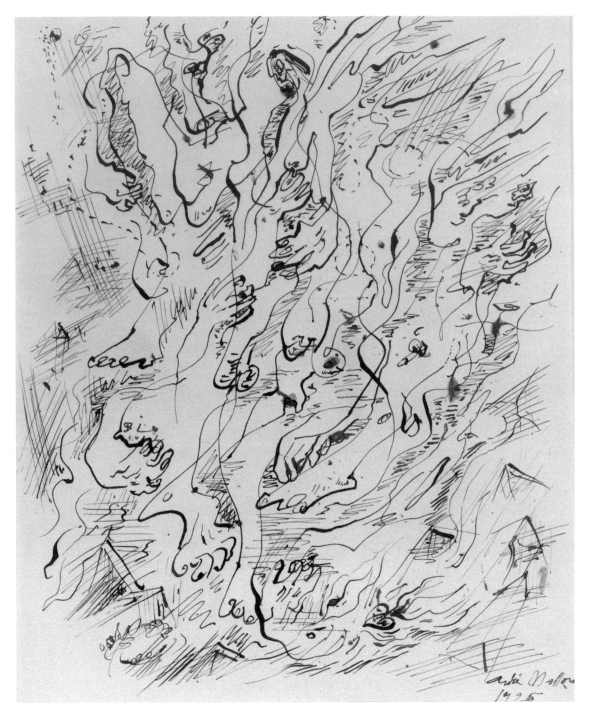

PLATE 12 · *18*

Animal pris au piège —

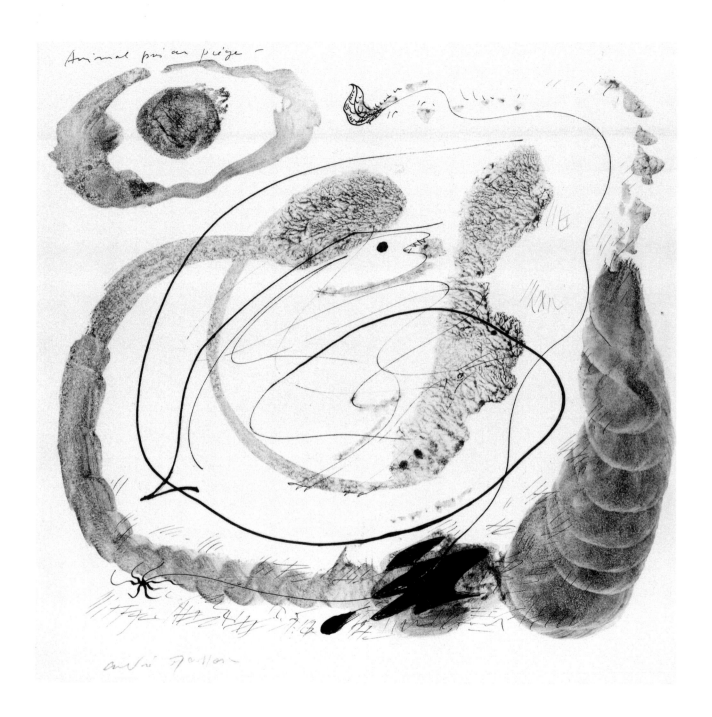

andré Masson

PLATE 13 · 32

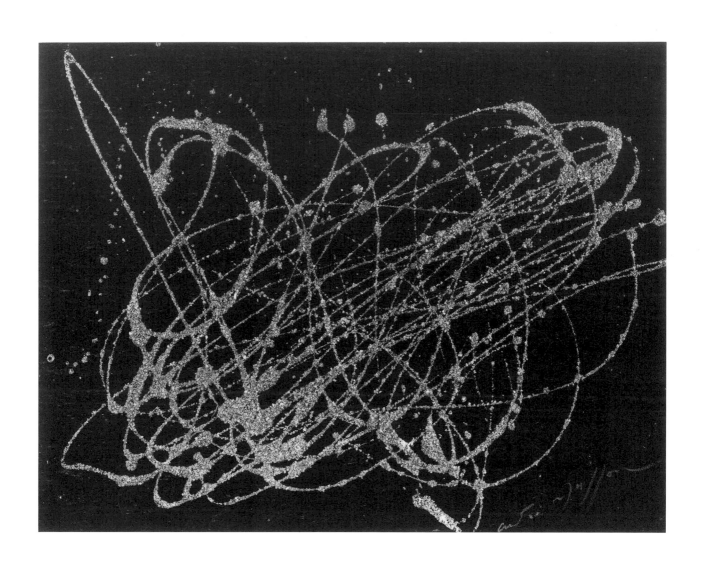

PLATE 14 · *132*

on Masson's part to find an 'equivalent' to automatic writing, but have roots deep in his own practice.

Nonetheless, their importance to Surrealism was quickly realised, and they have in a sense remained the most vivid demonstration of automatism. Masson's own accounts of the process, however, reveal, through their own variations, certain crucial differences between his approach to it and that of the orthodox Surrealists. The definition of Surrealism from the first *Manifesto* ran: 'Pure psychic automatism, by which it is intended to express, either verbally, or in writing, the true functioning of thought. The dictation of thought in the absence of any control exerted by reason, and outside any aesthetic or moral preoccupation.' [16] Masson's account in 'The Painter and his Fantasms' reveals the fragility of the state of mind in which automatic drawings could be undertaken:

'a) The first condition was to liberate the mind from all apparent ties. Entry into a state similar to a trance.

b) Abandonment to interior tumult.

c) Rapidity of writing.

These dispositions once attained, under my fingers involuntary figures were born, and most often disturbing, disquieting, unqualifiable. The slightest reflection broke the charm. But when in the end the images appeared, I could not prevent a movement of shame – an indescribable unease – combined with a vengeful exultation, like a victory carried over some oppressive power . . .' [17]

Masson felt with some justice that the problem of non-equivalence between automatic writing and drawing was never faced by the Surrealists, who, he said, in the end 'gave primacy to the *collage* of heteroclite images (Max Ernst's fief.) It's because in the end his [Breton's] definition of automatism was confused: no distinction between image in the Freudian sense, metaphor and analogy.' [18] The term that had 'imposed' itself for Masson was 'analogy', which could be better married to his conception of the moving flux of nature than could metaphor, a more static term, and also better described a line which was still *flottante*, not tied to the representation

of a single object. Two further statements by Masson reveal the direction that his concept of automatism took:

'Materially, a little paper, a little ink.

Physically, you must make a void in yourself; the automatic drawing taking its source in the unconscious, must appear as an unforeseen birth. The first graphic apparitions on the paper are pure gesture, rhythm, incantation, and as a result: pure scrawl. That is the first phase.

In the second phase, the image (which was latent) reclaims its rights.' [19]

Here, the Freudian/surrealist language (unconscious, latent), persists, but there is the hint of another model when Masson introduces the notion of the void: the philosophy of Zen. Masson makes this reference quite explicit when he writes in relation to his return to an 'automatic' linear spontaneity in the new series of sand paintings (1954–60), 'Make a void in yourself, primary condition, according to the Chinese aesthetic of the art of painting.' [20] These models are in fact quite contradictory. On the one hand there is the orthodox surrealist belief that interior unconscious forces could be heard if the rational and conscious mind could be bypassed; as Breton put it in the first *Manifesto*: 'If the depths of our mind contain within it strange forces capable of augmenting those on the surface, or of waging a victorious battle against them, there is every reason to seize them . . .' [21]; and automatism was one way of doing so. On the other hand, Masson proposes a suspension of the self in order to achieve harmonious identity with nature. It is not just a case of restating the problem of the passivity of the automatic state: one is essentially self-centred, the other is not. In 1959 Masson published an essay on Chinese painting in which he contrasts the Eastern and Western attitudes as follows:

'The essential for the Zen painter resembles in no way what the Western artist understands by this term. For the Chinese artist or his Japanese emulator . . . it is a way of existing – in the deepest sense – and not, as for us, a way of acting.

. . . What holds us back in our Western fetters is a certain will to power which is first exercised on ourselves and then on others: to put heavily our imprint on everything, to violate them in order better to appropriate them and impose oneself

on them: we must renounce this. "To conquer, but not to wound things," Buddhist painters of illumination will never invalidate this Taoist precept.'[22] Without subscribing to the illusion that such a state was open to him, Masson, like the Dadaists before him, valued a system in which man did not assert dominance.

Although Masson's close interest in Zen dates from a later period, and the descriptions of automatism are retrospective, it is not unreasonable to propose a continuity of attitude, in the emphasis on an opening outward rather than inward. In the third issue of *La Revolution Surréaliste*, (15 April 1925) several of Masson's drawings are reproduced on a large scale; one is given a full page, opposite Artaud's 'Letter to the Schools of Buddha.' This, like Artaud's other open letters a passionate attack on the narrow logic and rational materialism of the West, contains the phrase 'The metamorphoses of life are multiple'; this reverberates in the drawing beside it, in which a fruit, a female torso, a balustrade and a meteor (in place of a head) appear in the midst of sweeping lines. The sense of fluidity and change is very strong, completing the transmutation of the cubist 'plastic metaphor' into surrealist metamorphosis.

The wandering line of the drawings quickly made its appearance in the oil paintings, where it flows over, combines with and gradually replaces the cubist grid. In 1927 the sense that oil painting lacked spontaneity, and that he needed a new material/surface to provoke imagination and introduce chance brought him to experiment with sand. On a canvas laid flat on the floor, Masson threw small pools of glue, which he then manipulated so that 'they took on the aspect of Leonardo's wall'.[23] On this, he spread sand, sometimes in single patches, sometimes repeating the process to end with a thickly textured 'wall.' On this he added a few lines as quickly as possible, and a few spots of colour. Parallels can be drawn with Ernst's *frottages*, but there is again a noticeable continuity with the paintings:

'Themes: wounded birds, birds pierced by arrows. Birds enclosed in the crystal, ecstatic, transfigured. Dead horses, justicial horses, dying horses, appearing, becoming volatile, reviving, new Bestiaries where metamorphoses reign: the leaf-bear, the fig-cock . . .
The figure of the woman becomes dominant.'[24]

The figures are almost always headless, or with heads of animals, but the animals do not stand in for man. Masson's man-animal metamorphoses can perhaps be seen as the background for Bataille's dictionary entry on 'Metamorphosis' in *Documents*, in which, continuing his attack on idealism, he writes:

'Habit cannot prevent a man from knowing that he lies like a dog when he speaks of human dignity among the animals (in a zoo). For in the presence of *illegal* and necessarily free beings (the only true outlaws), the most disquieting envy carries him beyond the stupid sentiment of practical superiority . . . So many animals in the world, and so much we have lost: innocent cruelty, the monstrous opacity of the eyes . . . horror linked to life like a tree to the light.' [25]

The violence in *The Battle of Fishes*, with splashes of blood on the sand, again recalls *Les Chants de Maldoror*: the battle of the sharks fighting over bodies from a shipwreck, which ends with the ecstatic coupling of Maldoror and the female shark, a scene Masson later chose to illustrate.

Masson has said that almost all his automatic drawings have an erotic undercurrent, which was quite unlike the erotic drawings of 1922: this eroticism was disquieting rather than 'efficacious'. Without wishing to argue for too close a correspondence, Masson's concept of analogy and the kind of eroticism he refers to can be linked with a text of Bataille's written in 1927, though not published until 1931, when it appeared with illustrations by Masson: *L'Anus Solaire*. (In 1928 Masson had illustrated Bataille's erotic masterpiece *L'Histoire de l'Oeil*.) *L'Anus Solaire* refuses the notions of order and hierarchy of the old mythical models of the universe:

'Everyone knows that life is parodic and lacks an interpretation.

Gold, water, the equator or crime can indifferently be stated as the principle of things'.

He proposes two principal movements: sexual and rotatory, which reciprocally transform themselves into one another:

'Thus we see that the earth in turning makes animals and men couple and (since the result is both the cause and what provokes it) then men and animals make the world turn.'

Earth, the cosmos, the organic and inorganic worlds move and interpenetrate sexually ('From the movement of the sea, uniform coition of earth with sea, proceeds the organic and polymorphous coition of earth and sun.')

Bataille's presentation of the whole universe moved by desire and constantly coupling finds a visual parallel in Masson's landscapes (*Terres Erotiques*); these are also, however, informed by Masson's reading of Bachofen, whose investigation into ancient matriarchal societies, traces of which persist in the oldest myths, *Mutterecht und Urreligion*, first published in 1861, also interested Lacan. Bachofen's idea of Mother Right 'confirmed Masson in his own tendency to associate the feminine image with elementary telluric forces.' [26] Also, the argument that myth was a 'reliable historical source' attracted Bataille and Masson, whose socio-ethnological study of mythology was deeply affected by the idea that it could be the manifestation of early buried cultural stages.

Bachofen wrote, for instance: 'Of the three great cosmic bodies – earth, moon and sun – the first is the vehicle of maternity, while the last governs the development of the paternal principle; the lowest stage of religion, pure tellurism, insists on the primacy of the material womb.' [27] Bachofen also, in a model that influenced Nietzsche, opposed Apollonian and Dionysian forces: '[Apollo's] paternity is motherless and spiritual, as in adoption, hence immortal, immune to the night of death which forever confronts Dionysos because he is phallic.'

Eroticism was central to both Breton and Bataille, but their ideas of the erotic, as Masson has said, were totally different. For Breton, *L'Amour Fou* was the experience which transfigures life. Eroticism for Bataille involved the exploration of the limits of sensation; it was related to the instinctual life of man, man without reason, without a head, and also to the Dionysian rapture.

The surrealist 'Succint Dictionary of Eroticism' contained the following entry on Bataille: '. . . in whom eroticism, fusing with nostalgia for sacrifice, and anguish, explodes in a black laugh.' [28] For all of them, Sade was, as Masson put it, 'tutelary'. However, while for the Surrealists he was a 'visionary, revolutionary and moralist', for Bataille his eroticism was primarily transgressive. Masson saw Sade as a rational-

ist, seeking the *laws* of eroticism; his interest was aroused more by the settings of the events in *Justine* and *Juliette*, and their analogical intensity: 'you have to go to *Juliette* to find the height of the imagination of the "divine" marquis: great Italian *décors* against the background of a volcano in eruption as it should be, and blazoned with blood . . .'.[29] Such settings appear in Masson's own drawings.

Masson and Bataille were to collaborate intimately for nearly ten years, from *L'Histoire de l'Oeil* to *Acéphale* (1936-37).[30] It was not just a matter of producing illustrations for Bataille's texts; *Sacrifices*, for instance, were written to accompany an existing series of drawings by Masson, of the gods who died: Mithra, Orpheus, Le Crucifié, Minotaure, Osiris. The notion of sacrifice was extended during the *Documents* period in ethnological and sociological directions, and increasingly in the Thirties explored in the context of mythology. It is plausible to trace Masson's *Sacrifices* drawings, especially those of Mithra and the Minotaure, to the studies he made when he visited the abattoirs at La Villette in 1929 in the company of Eli Lotar, whose photographs of these slaughterhouses accompanied Bataille's dictionary entry in *Documents* on 'Abattoir'. This text introduces the *sacré* in shocking conjunction with physical horror:

> 'The abattoir has its source in religion in the sense that the temples of past times . . . served a double function, being used at the same time for prayer and killing. From this results without any doubt the shocking coincidence between mythological mysteries and the lugubrious grandeur of places where blood flows . . .'[31]

Themes of violence and aggression multiply, and for two years (1931-3) Masson painted and drew almost nothing but *massacres*. Several of these were reproduced in 1933 in the first issue of *Minotaure*, and it must have been with Masson in mind that Tériade spoke in the same issue of young artists whose work was dynamic and violent, and re-opened a line to the Baroque. The reproductions of Rubens' *Martyrdom of St Ursula*, or Tintoretto's *St Catherine*, were expressly chosen in this connection.[32]

Masson and Bataille's shared interest in the *sacré*, and the 'darkest myths of ancient

Greece', as Masson put it, culminated in the publication of the review *Acéphale*, of which just three issues appeared. The first was published in June 1936, just after the failure of the brief alliance between Bataille and the Surrealists under the name of Contre-Attaque. The attempt to form a common political front against the threat of fascism among intellectuals of the revolutionary left, and its collapse, is relevant to *Acéphale*, whose opening text, 'La Conjuration sacrée' argued '. . . if nothing can be found beyond political activity, human desire would encounter nothing but the void.' The cause of the conflict between Bataille and the Surrealists at this point is clearly high-lighted in the following passage from a letter by Masson to Bataille, questioning the validity of the enterprise:

'The question is 1) are there yes or no irrational elements in man's mind? 2) are these irrational elements inseparable from all human life? If, like me, you answer in the affirmative you are obliged *to hate first of all marxism* because its bases are solely rationalist and utilitarian . . .' [33]

Bataille was of a similar opinion; texts like 'Front populaire dans la rue' [34] alarmed the Surrealists who felt that it had gone beyond being a study of the irrational nature of popular insurrection, and itself manifested fascist tendencies. Sensible to this charge, in the second issue of *Acéphale*, which was devoted to Nietzsche, Bataille defends him against the use made of him by the fascists.

The image of *Acéphale*, the headless, was created by Masson: in one hand he holds a flaming heart, in the other a sword. The absent head replaces, or masks, the genitals, as skull. The closeness of Masson and Bataille at this time is referred to by Bataille at the end of 'La Conjuration sacrée':

'What I think and what I represent, I do not think or represent alone. I am writing in a cold little house in a fishing village, a dog has just barked in the night. My room is next to the room where André Masson is moving around happily and singing: at the very moment I write this, he has just put on the gramaphone the record of the overture of *Don Giovanni*; more than any other thing, the overture of *Don Giovanni* links what has disappointed me in life to a challenge that opens, for me, onto a rapture beyond myself.' [35]

The drawing in the second issue of *Acéphale* accompanying the extract entitled 'Héraclite' from Nietzsche's *Philosophie à l'Epoque tragique de la Grèce* brings together several of Masson's preoccupations of the time: the *acéphale* (who also appears as Dionysos in a drawing in the final issue) is stretched between earth and a sky filled with meteors and flames. The earth is shown as the rocks of Montserrat, in Spain, where Masson had passed a whole night in a state of rapture: an experience he refers to in many paintings of 1935, and of which he wrote a poem, 'From the heights of Montserrat':

> 'Everything must return to the original fire
> Tempest of flames
> Thus spoke Heraclitus . . .' [36]

'Because Heraclitus saw the law in the combat of multiple elements, in fire the innocent game of the universe, he was to appear to Nietzsche as his double.' [37] The connection between the pre-Socratic philosopher Heraclitus, and Nietzsche, was of great importance to Masson and confirmed for him a genealogy of thought. He had first read Heraclitus at the age of about twelve, and maintained his interest in pre-Socratic philosophers in a spirit of conscious opposition to Plato, to the Socratic 'theoretical optimist, who, strong in the belief that nature can be fathomed, considers knowledge to be the true panacea.' [38] In 'From the heights of Montserrat' Masson names Heraclitus, Paracelsus, and Zarathustra

> 'And thou Zarathustra eye of light
> At the centre of a terrible and joyous world . . .'

as those whose experience of the world, of man in nature, argued for a knowledge of it that transcended reason:

> 'Things themselves, in the solidity and fixity of which the narrow head of man and animal believe, have no independent existence. They are the peals and lightning flash of brandished swords, the glitter of victory in the combat of contrary qualities . . .' [39]

At the end of the Thirties, Masson was reconciled with the Surrealists; in 1941 he wrote with Breton, en route to the USA, 'Le dialogue créole entre André Breton et

André Masson'. Much could be said of their shared interest in American Indian thought, of their response to the overwhelming fullness and exuberance of the natural world in America. Surrealism itself shifted sensibly towards a greater interest in mysticism and magic. However, I would like to end with the text Breton wrote on Masson at the end of the Thirties, just before the European catastrophe of the second World War, and the journey of Breton and Masson into exile in America; a text which, while recognising the ceaseless ontological enquiry that fuelled Masson's work, and its exalted dynamism, at the same time seeks to bring those qualities into relation with the historical conditions of the moment, in terms of that complex balance the Surrealists sought between art and life.

'It is a damning fact that art in France, at the beginning of 1939, appears to be mainly concerned with hiding the sickness of the world under a carpet of flowers. While the winds of destruction are howling under every door, certain distinguished painters seem to be trying to give the impression, judging from what they are exhibiting, that life is simply floating along gently and gracefully. At the very hour when Barcelona is overwhelmed by misery in a hellish political climate, and when elsewhere the days of freedom seem to be numbered, these artists' work utterly fails to reflect this epoch's tragic sense of dread, their compass-needle continues obstinately to point to 'set fair' and their heads are invisible, tucked firmly under their multicoloured wings. If we are to believe the themes they choose, and the way they deal with them, they are conscious only of the pleasures of the table and the charms of intimacy conceived entirely within the framework of luxury . . . We are not, of course, suggesting for a moment that artistic themes should be tied strictly to actuality; on the contrary. And we continue to believe that art must, above all, be love rather than anger or pity. But we still condemn as tendentious and reactionary any image in which the painter or poet today offers us a stable universe . . . It is high time to react against the whole idea of the work of art as an inexhaustible *ribbon* at so much a foot . . . and to substitute for it the concept of the work of art as a *happening* (interpreting perceptible bifurcations and breaks in time, and abandoning any ridiculous idea of formal perfection in favour

of the power of revelation and that alone). A taste for taking risks is undeniably the principal motivating factor capable of urging mankind forward along the path of the unknown, and André Masson has developed this taste to the highest possible degree. No other imagination is so firmly gripped by the great questions which have been posed agonizingly down the centuries, right up to the present day, by Heraclitus, the Cabbalists, Sade, the German romantics and Lautréamont, and no imagination has offered them a more sympathetically attuned field of reaction. Yet his imagination is also absolved from these questions by virtue of the irresistible call of life which he is always striving to answer by tracing life back to its very source. It is this ambition that has led him to create his *metamorphoses*.' [40]

DAWN ADES

1. André Masson *Le Rebelle du Surréalisme: Ecrits* edited by Françoise Will-Levaillant collection Savoir, Paris 1976 p. 40 (author's trans.).

2. Michel Leiris 'En Fête avec André Masson' *André Masson* Museum ot Modern Art, New York 1976; Centre Georges Pompidou, Musée National d'Art Moderne, Paris 1977, p. ix. This study contains important texts by William Rubin and Carolyn Lanchner.

3. Masson *Ecrits* op. cit. p. 71.

4. André Breton *Surrealism and Painting* tr. Simon Watson Taylor, Icon Editions, Harper & Row, New York and London 1972 p. 36.

5. Georges Limbour 'André Masson, dans le feu de l'inspiration' *Dans Le Secret des Ateliers* L'Elocoquent, Paris 1986 p. 18.

6. Masson '45 rue Blomet' *Ecrits* op. cit. p. 77

7. Masson's letter to Breton of 2 September 1925 [*La Révolution Surréaliste* no. 5 October 1925] affirming his commitment to class struggle, indicates the relative orthodoxy of his involvement with Surrealism at this period.

8. See the essay in *Dada and Surrealism Reviewed*, on *Documents*, the review edited by Bataille 1929–30, meeting place of the dissident Surrealists like Masson, Desnos and Leiris, against which the orthodox Surrealists mounted a 'punitive expedition' – Masson 'Le soc de la charrue (Georges Bataille)' *Ecrits* op. cit. p. 75.

9. André Masson 'Je Dessine' (texts selected by Will-Levaillant) *André Masson: 200 Dessins* Musée d'Art Moderne de la ville de Paris 1976, n.p.

10. See Lanchner, 'André Masson: Origine et Développement' in *André Masson* op. cit., on the automatic drawings of Austin Spare and their relationship to the visionary art of William Blake. Blake's work was introduced to Masson by Aragon in 1925.

11. Paul Klee *Creative Confession* (1920), quoted in G. di San Lazzaro *Klee*, London 1964 p. 108.

12. 'Je Dessine' op. cit.

13. Comte de Lautréamont (Isidore Ducasse) *Les Chants de Maldoror* (1869) Libr. Jose Corti, Paris 1963 p. 136 ff.

14. *André Masson* op. cit. p. 93.

15. For a study of Masson and Piranesi, see Françoise Will-Levaillant 'L'Image Littéraire Revisitée: André Masson et Piranèsc' *Psychologie Médicale* 1985, 17,9: p. 1395–1402.

16. André Breton *Surrealist Manifesto* Paris 1924 (author's trans.).

17. André Masson 'Le Peintre et ses Fantasmes' *Ecrits* op. cit. p. 32.

18. 'Je Dessine' op. cit. n.p. (from *Mythologie d'André Masson* J.-P. Clébert, Geneva 1971).

19. Masson 'Propos sur le Surréalisme' (1961) *Ecrits* op. cit. p. 37.

20. 'Divagations sur l'éspace' in *Le Plaisir de peindre* Nice 1950, p. 147. The post-war sand paintings are much more abstract in appearance, and their titles, such as 'Meteors', 'Genesis', indicate the attempt to reach an 'ontological analogy between these gestures and a cosmic rhythm', as Françoise Levaillant has put it.

21. Breton *Manifestoes of Surrealism*. Ann Arbor 1969 p. 10.

22. Masson 'Une peinture de l'essentiel' (1959) *Ecrits* op. cit. p. 171.

23. 'Je Dessine' op. cit.

24. 'Je Dessine' op. cit.

25. Georges Bataille 'Metamorphose' *Documents* no. 6 Paris December 1929 p. 334.

26. Levaillant, in *Ecrits* op. cit. p. 55.

27. J.J. Bachofen *Mutterecht und Urreligion* (1861) tr. *Myth, Religion and Mother Right* 1967, with an introduction by George Boas which delineates Nietzsche's debt to Bachofen.

28. 'Lexique succint de l'érotisme' *Exposition Internationale du Surréalisme* 1959–1960 Paris p. 122.

29. Masson 'Note sur l'imagination sadique' (1947) *Ecrits* op. cit. p. 69.

30. See also Levaillant 'Masson, Bataille ou l'incongruité des signes (1928–1937)' *André Masson* Nîmes 1985.

31. *Documents* no. 6 op.cit. p. 329.

32. E. Tériade 'Valeur plastique du mouvement' *Minotaure* no. 1 Paris 1933 p. 45.

33. Masson letter to Bataille, Tossa, 6 Oct. [1935], *Ecrits* op. cit. p. 284.

34. Bataille *Oeuvres Complètes* tome I p. 402 (*Les Cahiers de Contre-Attaque* May 1936).

35. *Acéphale* no. 1. 24 June 1936.

36. André Masson and Georges Bataille 'Montserrat' *Minotaure* no. 8 Paris 15 June 1936 p. 50.

37. Introduction to Nietzsche 'Héraclite' *Acéphale* no. 2. 21 Jan 1937.

38. F. Nietzche *The Birth of Tragedy* Anchor Books 1956 p. 94.

39. Nietzsche 'Héraclite' op. cit.

40. André Breton 'Prestige d'André Masson' *Minotaure* no. 12/13 May 1939 p. 13, trans. Breton *Surrealism and Painting* op. cit. p. 151.

Note: The title given to this essay is that of an article by Masson 'Mouvement et métamorphose', dedicated to Georges Limbour, published in *Les Tempes Modernes*, Paris, October 1949.

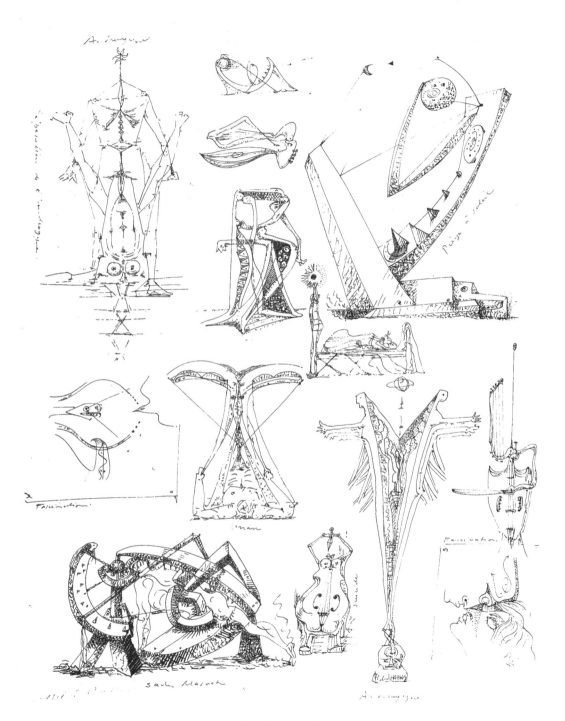

PLATE 15 · 66

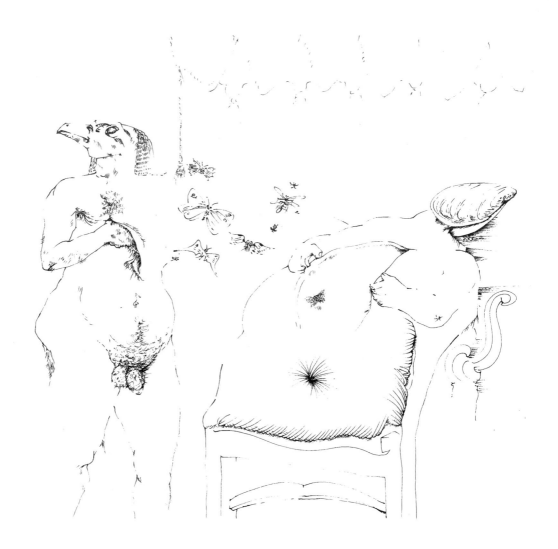

PLATE 16 · 71

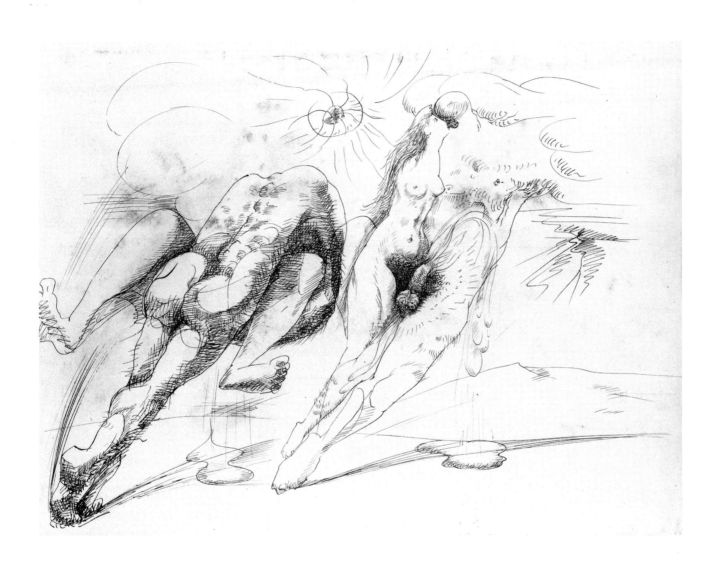

PLATE 17 · 72

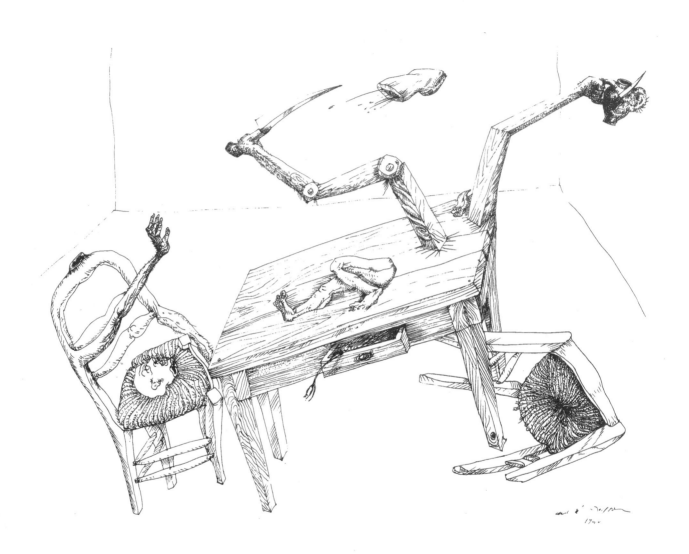

PLATE 18 · *78*

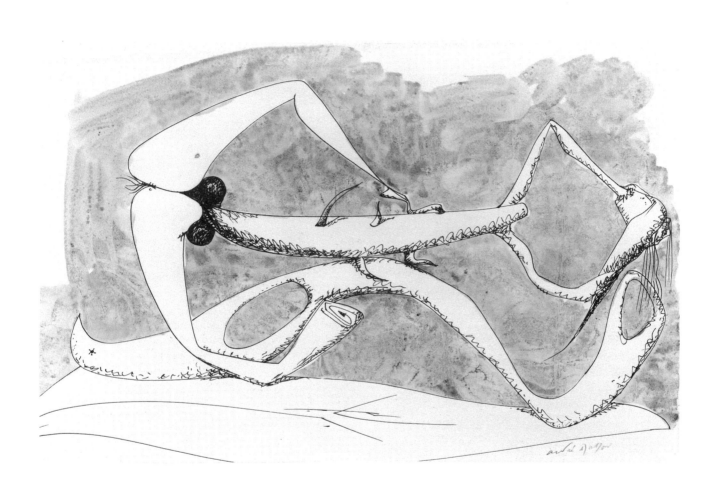

PLATE 19 · *79*

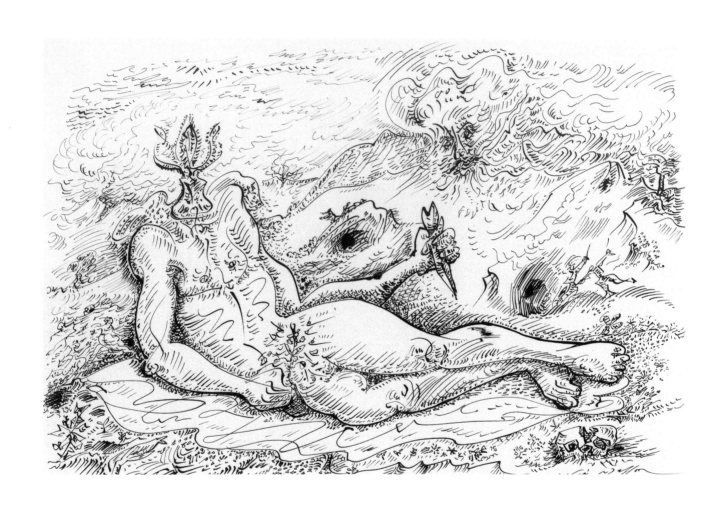

PLATE 20 · *144*

Line unleashed

The first problem – unresolved, perhaps insoluble – of art criticsm: to determine the point at which handwriting becomes calligraphy. Why is X a calligrapher when Y is not?

Another problem: to determine what, in an artist's actual working method, is so personal as to put his stamp upon the work, rendering any other signature superfluous. To make, as it were, a graphological study of his work instead of merely holding forth upon his themes.

A problem specific to André Masson's drawings: why is the line in these drawings so alive? and why is it so much more than a calligrapher's line? Just how does it differ from that of other superb draughtsmen?

More than a blank canvas does to the painter (a canvas is too thick, and weighed down still further by its stretcher), a sheet of white paper offers to the draughtsman that nothingness wherein the imagination, armed with the barest minimum of equipment – travelling light, as it were – can roam at will.

With drawing, everything happens as though by foreshortening, at accelerated speed, and you see it, literally, black on white.

Long practice of drawing, from a very early age. Whence, in part, that mastery of the technician who no longer has to bother with technique. Did not Goëthe – whom Masson admires and whom he has portrayed – say that you have to become rich in order to be able to forget all about money? And, closer to us in time, Max Jacob: 'Nothing to stop you warbling away like a bird . . . if your voice is well-pitched'.

Drawings made for the sake of drawing (not preparatory to paintings). Before Odilon Redon, Masson believes, this hardly existed.

Drawings without any pre-established subject. No pencilled underdrawing, either, for these works, mostly executed in pen and ink; whereas in the past, as Masson has pointed out to me, that was a fairly common expedient.

A drawing 'outlines itself', takes shape all at once, as you might say of something that comes into being before your very eyes.

These drawings are not *constructed*. They develop and build up within the non-existent space of the page, a space not hedged even by the fiction of a margin. 'Increase and multiply!' is the only precept which, without any Biblical connotations, they seem to follow.

It is, in effect, biology and not geometry that reigns.

Masson – whom Georges Limbour dubbed 'l'homme plume' – because of Paolo di Dono nicknamed 'The Bird', because of the wonderful birds in Masson's still-lifes, and (last but not least) because of an old woollen jersey he used to wear whose tufts gave him a feathered look – Masson draws as a glider pilot must, I imagine, steer his craft: finding favourable currents, delivering himself up to them and letting himself be carried along, steering no doubt but as though steering were a matter of adapting oneself, of acquiescing, rather than of exercising authority.

Thus the bird, active enough as it flaps its wings, nevertheless puts its whole trust in the wind and, docile, identifies the wind's will with its own.

Masson's manner is profoundly unitary or, if you will, *monistic:* he does not stand in front of objects but projects himself into the heart of the universe.

An 'ontological' art as opposed to the 'phenomenological' art of a Picasso or a Giacometti, for whom everything happens between the subject (themselves) and the object, real or fictitious, to be transcribed. The drama of the painter and his model seems alien to Masson.

Masson the antithesis of another great draughtsman, the draughtsman with the most caustic line, Toulouse-Lautrec. Nothing psychological in Masson, nor sociological, nor even documentary in the broadest sense (although on another level anyone is of course free to analyse the psychic and social underpinnings of his graphic works, for no one escapes History any more than we can shake off our own personal histories).

Balance, certainly, but a precarious or shifting one. As far back as in his earliest canvases, nothing appeared fixed: neither the vertiginous tables round which men drank, smoked or played cards; nor the trees in the Clamart woods with their slender trunks that seem to be flying forward, branches spreading like tentacles in the sky;

nor the objects in the still-lifes, never closed in upon themselves, often directly evocative of unbounded space (transparency of a drinking glass, evanescent flight of a bird, paper whorl spiralling towards infinity, post-card opening up a landscape inside a closed interior).

'Yes, but mind you blow up the scales afterwards!' was his answer to a painter friend greatly concerned with rationality and a properly balanced construction.

Much later, in Bavaria, Masson and I would go into ecstasies over the spectacle offered by the Rococo monuments' paradoxical balancing acts – real high velocity numbers. Here is how Masson defines what he aspires to, as an artist less interested in copying his sensation than in provoking it: 'A way of feeling in which the point of balance is reached when apparition and disappearance from sight merge into one'.

And in *Métamorphose de l'artiste* he also says: 'Something closer to the fortuitous and fleeting side of life, the unexpected aspects of nature, than to an architectural sense or a tendency towards ceremonial'.

To make fast the absence of fixity: that is what he attempts with boldness and accomplishes with mastery (the Italian *maestria*, with its festive overtones, is a better word here than the French *maîtrise*).

With his own personal handwriting – which is never anything but linear, and which transcribes nothing but his own words – Masson drives objects and beings forward to their fulfilment . . . or to bursting point.

Honour where honour is due. I am not forgetting it was Gertrude Stein who, very early on, coined the phrase 'André Masson's errant line'. What struck her must surely have been his line's vagabond ways, never at a standstill, so different from the line of the painters – Cubist and other – to whom she was accustomed.

Adventure of the line (*the* line because one would like to think there is only one – always the same line, now hiding, now reappearing), of the line which posits a being and metamorphoses it . . . In Masson's drawings it is rarely otherwise.

There are cases, however, where the being is simply posited – but then, not so much posited as *experienced* in some way. This is so in the rare drawings executed from nature.

And there is also the separate case of the purely descriptive drawings (*Massacres*, for example, where the drawing seems to reproduce a stage scene), or that of the graphic works which show fabulous beings or strange machines (mechanisms rich with potential action even when we see them at rest, static and inert), a little like those sketches pertaining to the engineer's art that we find in Leonardo.

In *Métamorphose* we read: 'The thread-like line is always a skeleton'.

Far from being a thin, constricting metallic thread, a length of wire, Masson's line will almost always have its upstrokes and its downstrokes in which, expanding, black will become a colour.

Sometimes, when it takes the form of a nude, it will appear like the diagram of a caress stored inside the hand.

Of Masson, a tailor or couturier of our time might say by way of advertisement that his is a 'young line'. Or else 'the arrow line'.

A line that moves, that is open, not one that closes or petrifies.

The lines, not the bodies or the objects, proliferate and burst into leaf here, generating metamorphosis.

'A movement that falls in love with itself' is how Masson once defined the mainspring and armature of his art.

Being thus generative, is Masson's line not destined from the start to be a myth-making one? What, after all, are many myths but essays in genetics?

His first known drawings – pen drawings, generally heightened with water-colour – were erotic ones: Edenic embraces evocative of an age before gravity, before rules of any kind, tangles of feminine bodies suggestive of cosmogonies. If this is so, is it not because very early on Masson recognised physical love – which is a matter of genetics! – as his major theme and because this fundamental theme was revealed, without his having sought it, in drawing rather than in painting, which inevitably is more premeditated?

Metamorphosis which the body undergoes by the mere fact of being bared, act of love, emergence of a myth, act of drawing: to Masson, all these are one.

Sometimes the metamorphosis crystallizes into a form of geology which, too, goes

back to times before the flood. Sometimes it takes place among ruins, like a Byronic orgy whose setting is an ancient temple or a *campo santo*.

In the first pages of his *Essai de sémantique* Michel Bréal asserts that all Indo-European languages are doomed to be figurative and that to say, for example, that 'the word *clou* takes an *s* in the plural' is already the beginning of a myth.

Are Masson's wonderfully free drawings not committed to a similar destiny, oriented in the same direction by their specific nature? With him, the line seems always to be experiencing a drama of its own as well as saying something to us – something that touches us very closely but that we had not discovered and that this form or this metamorphosis alone could reveal.

What, after all, do I mean when I say that Masson's automatic drawings generate myths? Is it not to misuse the term – as the word 'dream' is often misused? Would it not be better to speak, more simply, of *poetic creation*? Yet the fact remains that such creation almost always has a 'naturistic' side (term coined by Masson, who describes himself as a *naturiste* in *Metamorphose d'un artiste*) which makes it akin to many mythologies.

I would like to affirm that genesis is so often the subject of Masson's drawings because, when he draws, his mind is wholly absorbed by the genesis of the drawing itself; it is this genesis that engenders the other.

This proposition, however, can be turned round the other way. Has he not written: 'The true "subject" should be a revelation of the creative energy which animates the world. In no case an analysis of the objects and beings which make up the work'?

None of what is given at the outset may then be analysed: yet something of what already exists must be made felt.

Let us say that the very energy he sets out to express drives his pencil or his pen when he is drawing, so that there is absolute coincidence between that which reveals and that which is revealed.

Arrogant lines which only rarely deign to copy reality, lines which aim as little at stylisation in accordance with an aesthetic code as at reproducing a model from the outside or the inside.

Lines which call to one another, either in order to articulate themselves into a single whole or, scattered, in order to compose a picture whose empty spaces will be empty in appearance only.

Voluble lines which soar upwards, bend, break, obliterate themselves or resume their flight.

Lines modulated like voices, liturgically chanting a mythical or legendary text.

Melodious lines, as they ought to be coming from a music-lover's hand – a hand which 'grows wings', as André Breton said, winging skywards on a syllable.

Lines which discover, which assuredly learn but do not teach. Always lyrical, never didactic.

Line, more than stroke.

Drawing, more than drawn.

Lineage, perhaps, more than line.

For the enveloping line which contains the lateral pressure of what it encircles, Masson substitutes the rocketing line which suffers only one kind of pressure: the pressure that launches it and, never slackening, propels it throughout the length of its trajectory.

Line in motion, more than line endeavouring to outline a structure.

Not to transcribe (whether by a single stroke or by successive approximations of accumulated, more or less superimposed strokes), not to transcribe a reality extracted from the real as it commonly offers itself to us or a fantasy forged by the imagination, but to engender there and then something whose reality is beyond question.

As though it had to squeeze through an infinitely narrow bottleneck every inch of the way, the line pushes with all its might, a thin jet of wine that is merely the prolongation of the fine crystal tap from which it flows. Thus, perhaps, semen?

Not ideograms or appearances of ideograms such as those he has often used in his paintings, but lines which are intrinsically ideas, issued forth all at once from 'his virile reason in a thunderbolt', as we read in *Un coup de dés* . . .

Surely it was not by chance that Masson, already past his maturity, undertook to illustrate this book – having, at the start of his career, painted and drawn so many

gamblers who seemed threatened or already engulfed by a shipwreck or a cataclysm.

In Masson's work the line does as it pleased, just as the people in *War and Peace* are admirable in that they do not dance to their author's tune and instead of being 'characters' – more or less subtly drawn, but established once and for all whatever the complexity of the mosaic they compose – are living beings with all the incoherencies which that implies.

For Masson, whose chosen form of self-discipline is to walk as though blindfold, the line is more than Ariadne's thread; not only a guide through the labyrinth but the force that never for an instant stops pulling him, the land surveyor, forward in its wake.

It has to be said again: the lines, here, go their own sweet way. Without looking back, without regret, never 'denied' (as Masson said to me one morning on the terrace of the house where he spent his summers, the garden, like a kind of savannah, on one side and, on the other, the Montagne Sainte-Victoire, a little veiled, its profile jutting forward into the open sky). Left to their flight, their detours, their whims, their contradictions, Masson's lines roam freely and so guide the artist to the innermost recesses of his own self.

Instead of delimiting, they de-limit.

Lines that create, not lines that describe.

Lines that stir fires, not lines that tell tales.

Seeking, questioning lines that go forward to discover where all of them will have gone together.

More rapid than painting, drawing is better able to stick close to events. And so it was this mode of expression that Masson chose when, in 1936, he wanted to denounce the horrors of Franco's war. The wonder is that these violently polemical drawings go infinitely far beyond caricature and attain the same mythical level as his other drawings.

'The only satirical artist of our time', wrote Limbour, who praised our friend highly for having one day declared himself to be an artist of that category besides being the kind of artist we already knew him to be – without, for all that, denying that other self.

In the *Massacres* the line fairly constantly runs close to the broken or solid line of a technical drawing. Here the crystal rules, not the plant. And indeed, could a massacre be other than jagged? and could it do otherwise than partake of the mineral's hardness?

Lines, at all events, that are drier and more discontinuous, lacking that floral quality which, elsewhere, never ceases to make one think of some sort of resurgence of '*le modern style*' (although nothing would warrant seeing any proof of paternity in the resemblance). Are they perhaps so choppy, forced into such abrupt changes of direction, because where there is no fusion in metamorphosis there must be separation, antagonism, stiffness, killing?

But between metamorphosis and massacre there is no hiatus, for in many drawings the intermingling shapes interpenetrate and devour one another without losing their identity.

La Chimère au serpent: figure obtained in 1940 by the indefinitely repeated reproduction of a recurrent snake-shaped sign which – on a larger scale – appears to have been already present in Masson's mind and which is the 'snake' of the title. Turned upright to make a question-mark, this snake is primordial, it engenders everything. Signs that act as echoes, similar to those that gave body to other chimeras or female centaurs snatched from the lair of classical mythology.

Like the ropes or stalks in other works, this snake seems merely to give its name to the line's undulations.

Shooting stars, flourishes, curls of foam. Whether they be curved or straight, the path upon which, through him, his line strikes out is always a roundabout way, the only one along which you can be sure to go from surprise to surprise. (As Nietzsche spoke of the dance and the dove's step, so we may speak here of 'playing truant'.)

The space that encloses these trajectories is not a rigid one, it is not like a box, however large, but a space that is totally vacant, not even oriented.

Sometimes a caption is added to a drawing of Masson's so as to make its meaning perfectly plain. Or else it runs parallel to it, an expression in another register. But, being instantaneous, it never comes after the event.

No 'baptism' such as those, they say, Paul Klee used to have, still less any speculation (belonging to the sphere of Romantic irony) about the distance that separates the caption from that to which it is applied.

If we wanted to play on words, we could say that Masson's secret is that he always absolutely and blindly *toes his own line*. A matter of life and death, one might say, as though the line he drew were positively his lifeline, charged with infinite promise and winding its way between irreducible hazards.

Other approaches by way of a play on words:

high-tension lines,

lines of fire,

lines of force,

surely not skylines and surely not Plimsoll lines.

All punning aside:

lines that will be anything at all – nerves, arteries, veins, antennae, waves, fibres, furrows, lodes – rather than demarcation lines or frontiers.

In a talk he once gave, Masson contrasted the illustrative imagination with the plastic (his own, distinct in that respect from that of other Surrealist artists, whose approach is generally based on collage). The thought is spelt out more clearly in the talk's published text which appeared in the autumn 1961 issue of the review *Médiations:*

'The illustrative imagination comes close to hypnagogic vision – imagery that precedes sleep and is for the most part "realistic", after the fashion of a film. But of a film that has got stuck: such visions as we know, do not move. With the other kind – the plastic imagination – the process is different. You can say of non-illustrative painting that it makes itself while making itself. It does not copy a dream vision. This is why automatism – let us call it gestural – falls in the category of the plastic imagination. It does not have to account for itself: it creates within the very substance and spirit of the artistic realm.'

It is true that, generally speaking, there is nothing in the least dreamlike in Masson's paintings, let alone his drawings. Are they perhaps too lively, too wide-

awake, too *present* to be dream-like? But there are some imaginary cities – cities which proliferate, but their proliferation belongs to times immemorial, not to the present – that arouse a certain suspicion: they are so old, like ancient dream images asleep in a forgotten recess of the mind.

Truth to tell, what would an artist be if his art did not go beyond what he might say about it in the belief that he has got his own measure? and, *a fortiori*, if it never contradicted what the outside commentator might have to say about it?

Drawing as he conceives of it is the automatic technique *par excellence* employed by Masson, but there are others:

– sand thrown on surfaces covered with glue, which results (but here the result is manufactured, not supplied by a chance encounter) in something resembling the 'wall' on which Leonardo deciphered shapes that, later, he would bring to life;

– paint thrown on to the canvas;

– paint squeezed on to the canvas directly from the tube.

With these other techniques there are several stages: first the chance action itself, then a reading of its results (of the Rorschach test type) and, lastly, a repetition of the act in a properly painterly mode. But when Masson opts for drawing, creation is indivisible and occurs all at once.

Another pronouncement: 'To leave the domain of the linear imperative, to enter that of fluidity and transparency'.

This applies, of course, to painting, which he always wants to be as spontaneous, as unconfined as drawing – and which, moreover, is to be freed from the domination of drawing, so that all power may be restored to colours delivered from their contours, liberated in their very core through the absence of opacity. Masson's, the Nietzschean's profoundly libertarian nature: hatred of all shackles, of all constraints, of all imperialism. He alone is his god and master.

In 1918, 'Dadaist spontaneity' to which Tristan Tzara attributed the lion's share by making this term the sub-heading of a manifesto published in *Dada 3*.

In 1968, the 'spontaneity' invoked by Daniel Cohn-Bendit and other students of the movement of May and June.

Rosa Luxemburg, for her part, spoke of the 'spontaneity of the masses' for which, in her view, the decisions of a leading apparatus could not serve as a valid substitute.

Masson, whose works so often challenge by their very structure the polarity of nadir and zenith, base and summit, needs no authority other than his own in order to work as he does. But is there not a good lesson in spontaneity, truly an object lesson, to be learned from his drawings, and is it not this, perhaps, that makes them so modern, whatever the subject?

Admiration for painters such as Tiepolo, Boucher and Fragonard. A passion for Sade. A keen interest in Chinese and Japanese art. Rousseauism. Love of nature. Was Max Jacob right when he used to say in the early days of the rue Blomet – to our somewhat shocked astonishment – that Masson was an eighteenth-century artist?

Century-long misunderstood and astonishing indeed: frivolous in many respects, if you will, but how many great principles were seriously challenged (and sometimes quite lost their heads as a result) under cover of that light-heartedness!

Too sensual for its freedom not to slide easily into licentiousness, Masson's line expresses the sovereignty of desire, scorning ready-made ideas and, amourous or cruel, undermining foundations. Remember, too, that this is an artist with encyclopaedic knowledge, steeped in philosophy, eager to test everything and practising painting as a form of cabbala.

Masson's Nervalian side. He, too, was born in the Oise region; he too quested after a new childhood.

–Pythagoreanism;

('A pure spirit waxes greater under the skin of stones');

– The enchanted land:

– travel notes

(places, monuments or curiosities very reminiscent of *Nuits d'octobre*,

such as the rue Saint-Denis with its 'feminary');

– music;

– the German Romantics;

and, since his face has filled out, a faint resemblance, perceptible in his everyday

reality, 'with his boots off', more than in the always tense portraits, painted or drawn, in which he acted as his own model (an *illuminé* – a visionary – who could be a close relative of the author of *Les Illuminés,* but a relative on the wrong side of the sheets, sprung from some marriage of heaven and hell).

On the far side of culture, and however extensive his own, Masson – the unprejudiced innovator nurtured by the great masters of the past – returns to first sources, those that antedate the birth of the human arts. Like an ignorant traveller who sets out and, along the way, discovers everything afresh and is struck with wonder at everything. Putting his vast knowledge in parentheses, he thus achieves, at the end of the road, the innocence (or the extreme subtlety) of myth – a myth personal to him, of course, but which, if everyone were thus to retrace their own steps, ignorant and oblivious at once, would prove to belong to all.

Perhaps it will have fallen to Masson, the lover of the Far East and of Zen, to have invented a type of drawing, like a master of archery, the artist hits the target without taking aim.

At any rate he certainly knows what spring not ruled by seasons he is talking about when he speaks of the 'line's wayward spring' in Japanese painting.

If, before discussing anyone, it is a good idea to try following in their footsteps and doing as they do – advice once given by the inventor of the *Parti pris des choses* – then doubtless it should have been in aphorisms and, if only it were possible, in fireworks that one should have spoken of the drawings of André Masson.

For all their inadequacy, these notes seem more like their subject than would have been a well-constructed text from which all gaps, obscurities, tautologies, exaggerations and contradictions had been systematically eliminated.

What they lack most – as I know all too well – is to have been written with a pen sharp as the eye of a bird of prey, a pen dipped in sap or in blood. Flung down thus upon the paper in a single gesture, the imitation would have been perfect.

But I must tell myself that there is a fundamental contradiction in what I have just written. To speak of Masson as he draws would have required a *tabula rasa*, a clean sweep of everything, including the intention to speak about the drawings of André

Masson. And I must tell myself, too, that there would be little point in drawing or painting if the critic, whether or not his text was modelled on the work, could fully penetrate the mystery. For if there is an art that counts, it is the art which – without the artist's seeking to make it so – is by its very existence a critique of art criticism, and a critique vigorous enough to silence it.

MICHEL LEIRIS
Spring 1968 – Spring 1971
[translated by Anna Bostock 1987]
André Masson, Massacres et autres dessins
Hermann, Paris 1971

PLATE 21 · *47*

PLATE 22 · *48*

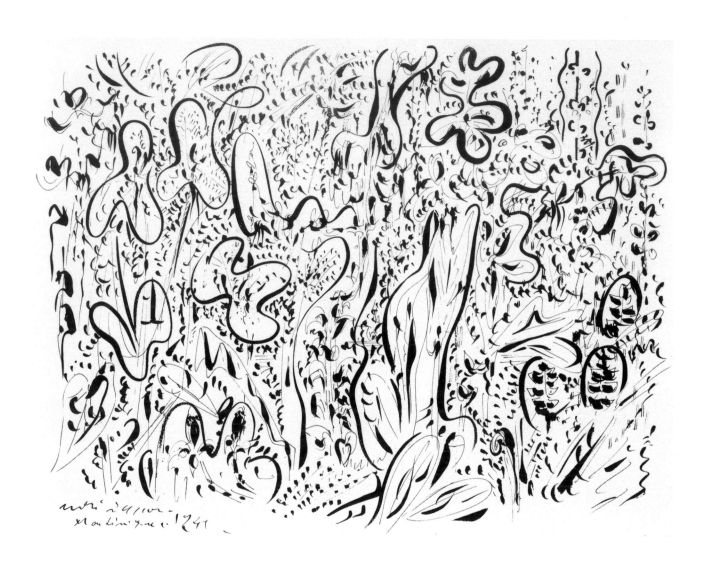

PLATE 23 · 83

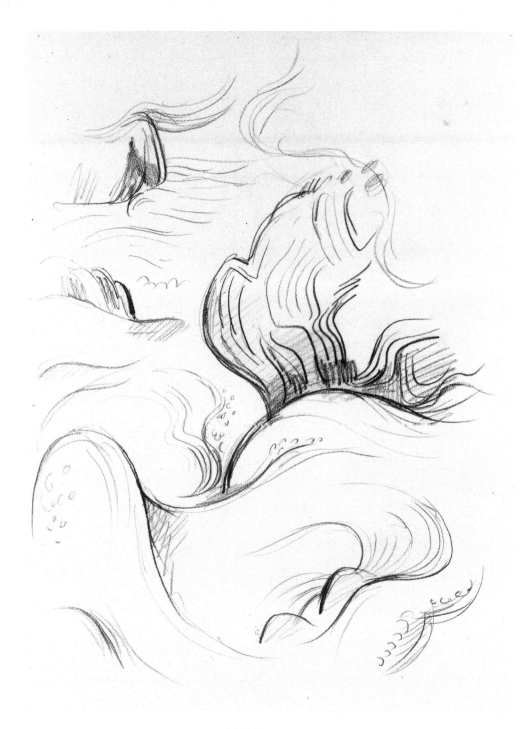

PLATE 24 · *112*

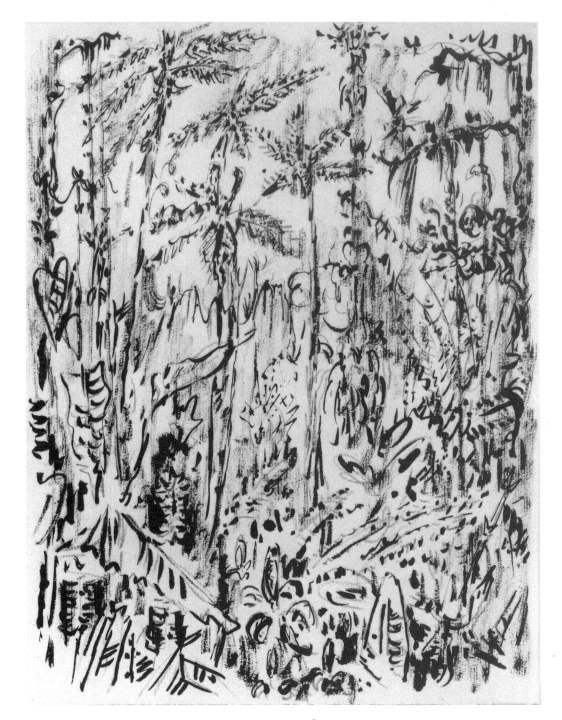

PLATE 25 · *82*

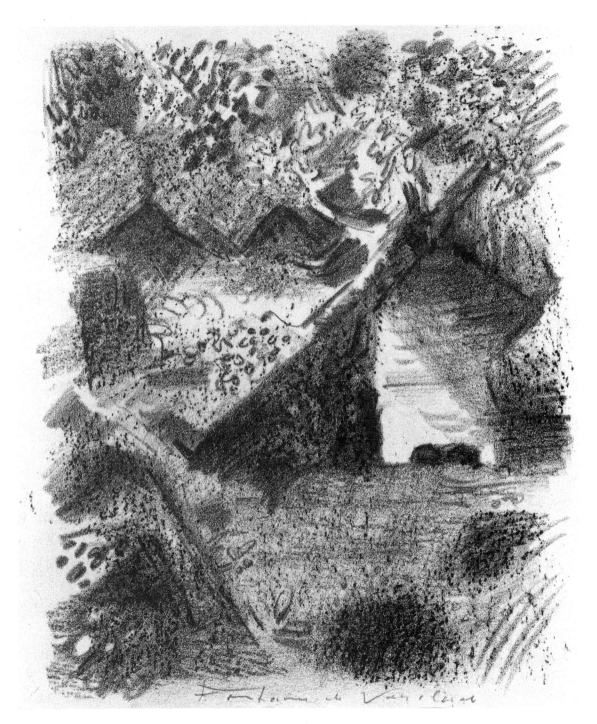

Fontaine de Vaucluse

PLATE 26 · *115*

Biographical note

André Masson was born on 4 January 1896 in Balagny, a small village near Senlis, in the north of France. His father Aimé ran a school. In 1903 the family moved to Lille and soon after settled in Brussels, where Aimé ran an agency selling wallpaper. Masson went to a primary school directed by Marist brothers.

At the age of eleven – considerably below the regulation age – he was admitted to the Académie Royale des Beaux-Arts et l'Ecole des Arts Décoratifs in Brussels. To earn a little money, he worked in the afternoons making designs for embroidery. His main teacher was the symbolist painter Constant Montald, and in 1912 he spent the summer at Montald's house in the country helping him on a project to decorate a church in the Ardennes. Montald's friend, Emile Verhaeren, the poet and collector – notably of Ensor – was impressed by Masson's talent and persuaded his parents to send him to Paris to study.

In 1912 he entered the studio of Paul Baudoin, who taught fresco painting at the Ecole Nationale Supérieure des Beaux-Arts, and found a place to live near the Musée du Luxembourg. In the spring of 1914, a grant from the Ecole des Beaux-Arts enabled him to spend a month travelling through northern Italy to study frescoes, which he did in the company of a fellow student, Maurice Loutreuil. In June he travelled to Switzerland and spent six months there, taking long walking tours and avidly reading Nietzsche. Meanwhile, in August, Germany declared war on France.

In January 1915, having returned to Paris, he enlisted in the infantry as a private. He fought in the battles of the Somme in June and November 1916 and then spent a freezing winter in the Aisne. On 17 April 1917 he was severely wounded. After a long period in various hospitals he escaped from a medical examination at barracks when his wound was ripped open by a doctor who insisted on raising his arm. He was incarcerated in mental hospitals until his discharge in November 1918.

After living briefly with his parents in Paris, in 1919 he joined Maurice Loutreuil in Martigues, where, in a hut overlooking the Etang de Berre, he began to paint. He

visited Collioure and then Céret, where he had frequent meetings and arguments with Chaim Soutine.

In the summer of that year he met Odette Cabalé; they were married in Céret on 13 February 1920 and then went to Paris, where they lived with his parents. On 3 November their daughter Lily was born. Masson, who had previously been earning a living at a ceramics factory, found a job as a night editor at the *Journal officiel*, but at the same time went on working in ceramics and also worked as a film and theatre extra and as a delivery boy; he had little time to paint. In 1921 he moved to 45, rue Blomet.

Between 1920 and 1923 Masson came to know Max Jacob, Jean Dubuffet, Georges Limbour, Joan Miró, Michel Leiris, Gertrude Stein, Ernest Hemingway, Juan Gris, Louis Aragon, Robert Desnos, Raymond Queneau, André Malraux, Antonin Artaud.

In 1921 his work was seen by Daniel-Henry Kahnweiler, who offered him a contract the following year and in May 1923 began including him in group exhibitions at his gallery, the Galerie Simon, where, in February-March 1924, Masson had his first one-man show.

André Breton came to that exhibition, bought *The Four Elements* and in September went to see the artist, inviting him to join the Surrealist group. Late in 1923 Masson had started experimenting with automatic drawing, and the first issue of *La Révolution surréaliste,* published in December 1924, reproduced two such drawings by him – the first of many works of his to be reproduced in the review.

In 1925 the first of numerous books illustrated by Masson, *Soleil bas* by Georges Limbour, was published. That year he met another writer who was to become a constant collaborator: Georges Bataille.

From the spring of 1926 on, he spent a year in the south of France, mostly at Sanary-sur-Mer, near Toulon. There, searching for a way of applying automatism to painting, he found he could do so through using sand and glue.

Back in Paris in the spring of 1927 he met Alberto Giacometti at the café du Dôme and later that year got technical advice from him in modelling his first sculpture,

Metamorphosis. Two years later he had Giacometti collaborate with him on the commission he had been given to decorate Pierre David-Weill's apartment.

In 1928 he again worked partly in the south of France, this time at Lavandou. From now on he tended to divide his time when in France between Paris and the South.

In 1929 an increasing sense of alienation from the surrealist group led him to inform Breton that he no longer wanted to adhere and later that year he was formally expelled. He was also divorced that year.

In 1930 he met Kuni Matsuo, a Japanese writer who led him to learn about Zen and Oriental art, which were to become primary sources of inspiration.

In 1931 Paul Rosenberg began buying work by Masson and, following a break between the artist and Kahnweiler at the end of the year, had him under contract for two years, after which he returned to Kahnweiler. He spent most of 1932 at St-Jean-de-Grasse on the Côte d'Azur, where he saw hardly anyone except for Matisse, briefly, and H. G. Wells, his neighbour, whom he dined with every week.

In February–March 1933 he carried out his first major work for the theatre, the décor and costumes for the symphonic ballet *Présages*, choreographed by Léonide Massine to Tchaikovsky's Fifth. Following a dispute with the company, he spent a fortnight as Matisse's guest in Nice.

On 6 February 1934 he witnessed a charge of Republican Guards during the Stavisky riots in Paris and decided to exile himself from France. In March he left for Spain with Rose Maklès. They were married on 28 December. Their son Diego was born on 21 June 1935 and their son Luis on 26 September 1936. In December 1936 the family returned from Spain and settled in the countryside at Lyons-la-Forêt in Normandy.

A reconciliation with Breton in 1937 led to Masson's taking part in the International Surrealist Exhibition in Paris in 1938 and to Breton's contributing a major article on him to an issue of *Minotaure* in 1939 for which he designed the cover.

When France fell in June 1940 he fled with his family to Fréluc, Auvergne. There, prevented from painting through lack of materials, he worked mainly on drawings

for *Anatomy of my Universe*. In December they moved to Marseilles, where they joined Breton and other intellectuals and artists who were trying to leave Europe for America. Masson and his family spent the winter in a hunting lodge lent them in nearby Montredon. They embarked on 31 March 1941 for the United States via Martinique, where they spent three weeks, in the company of Claude Lévi-Strauss and Wifredo Lam. They arrived in New York on 29 May. Customs officials confiscated a number of Masson's drawings, judging them obscene.

In October 1941 the Massons moved into a house in New Preston, Connecticut, where they stayed for the next four years. Masson exhibited principally at Curt Valentin's Buchholz Gallery, New York. The friends he saw were mainly Alexander Calder, Arshile Gorky, Yves Tanguy, Kay Sage, Georges Duthuit, Eugene and Maria Jolas. He never learned to speak English.

In 1942 *Mythology of Being* was published – the first of several books with both drawings and texts by Masson.

In 1943 there was a fresh break between Masson and Breton, one that was never to be repaired.

In the summer of 1945, shortly after the liberation of France, Masson, on a farewell visit to the Metropolitan Museum in New York, was struck by Monet's *Cliffs at Etretat* in a way that was to affect his work deeply in the next decade. It was at about this time too that he first met Jean-Paul Sartre.

In October the Masson family returned to France. After three weeks in Paris they set up house at La Sablonnerie near Poitiers. At the end of the year a one-man show of works brought back from America renewed his association with Kahnweiler, whose gallery was now the Galerie Louise Leiris.

In October 1947 the family moved to the Villa L'Harmas at Le Tholonet, near Aix-en-Provence.

In September 1951 Masson visited Italy for the first time since 1914. He has subsequently gone there with great frequency.

In 1953 the family moved up the road to a house called Les Cigales, the first property Masson had ever owned. He commissioned the celebrated architect Fernand Pouillon to design his studio.

From 1955 Masson started to spend a large part of the winter in Paris. In 1958 he rented an apartment at 65 rue Ste Anne. In 1963 he gave this up for one at 26 rue de Sevigné in the Marais.

In 1964 he had his first large-scale retrospective in a public gallery, at the Akademie der Kunst, Berlin, and the Stedelijk Museum, Amsterdam.

In 1965, at the request of André Malraux, then Minister for Culture, and Jean-Louis Barrault, he carried out a decoration for the ceiling of the Théâtre de France at the Odéon.

Physical disability confined Masson to a wheelchair around 1977 and forced him to give up, first painting, at the end of the '70s, then drawing, in the early '80s, and finally etching, in 1985.

Rose Masson died after a lengthy illness in August 1986. Masson now lives entirely at the rue de Sevigné, but goes on taking occasional trips abroad.

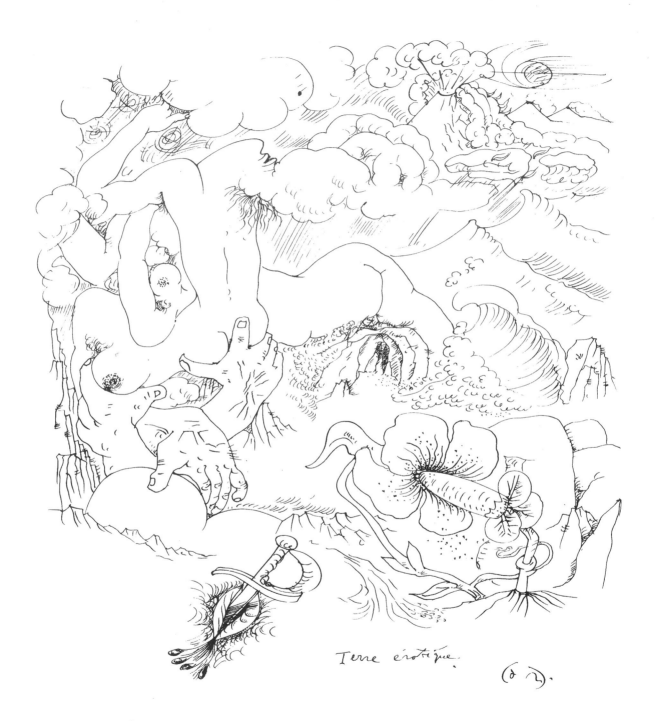

Terre érotique.

PLATE 27 · 60

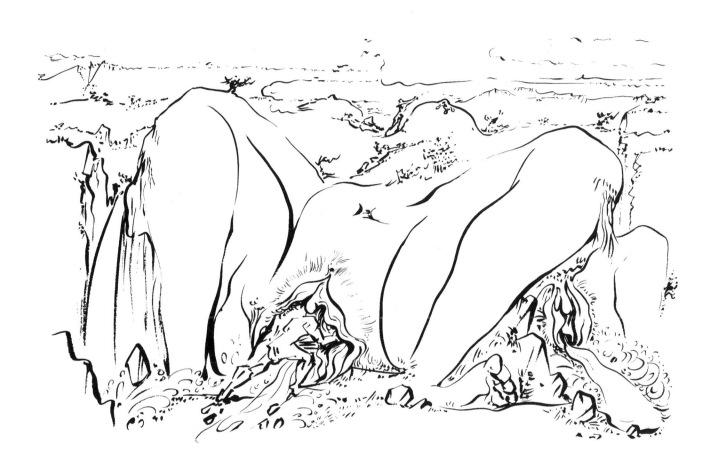

PLATE 28 · *74*

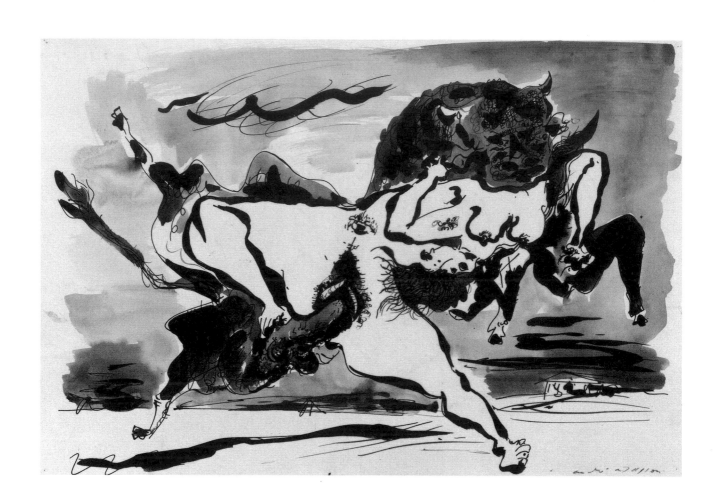

PLATE 29 · 87

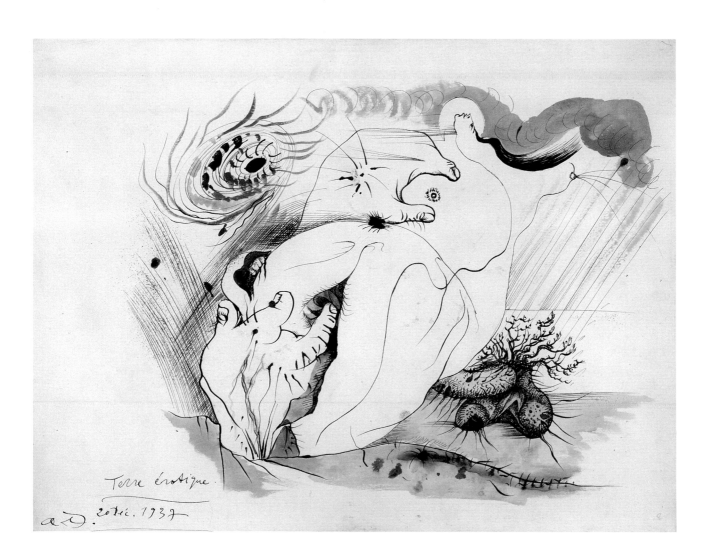

Terre érotique.

aD. 20 fév. 1937

PLATE 30 · 55

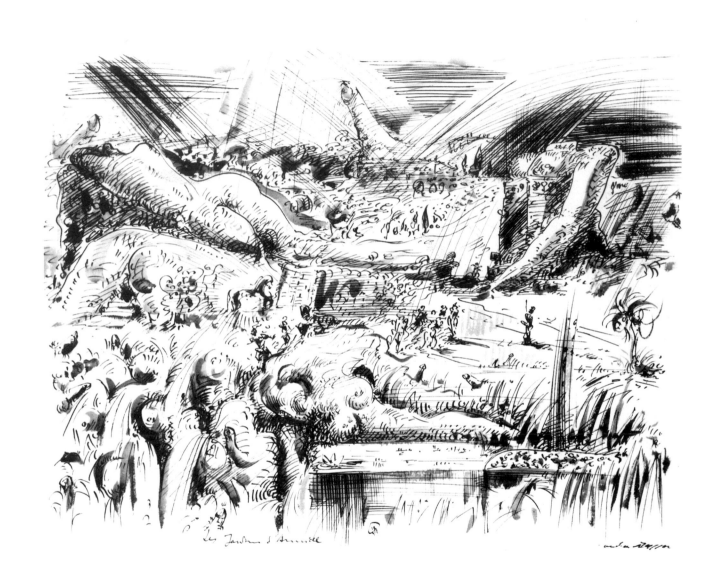

Les Jardins d'Armide

André Masson

PLATE 31 · *142*

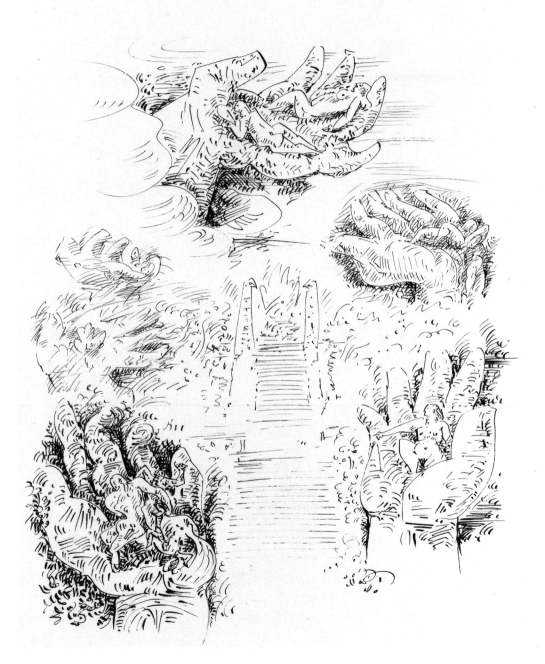

PLATE 32 · *101*

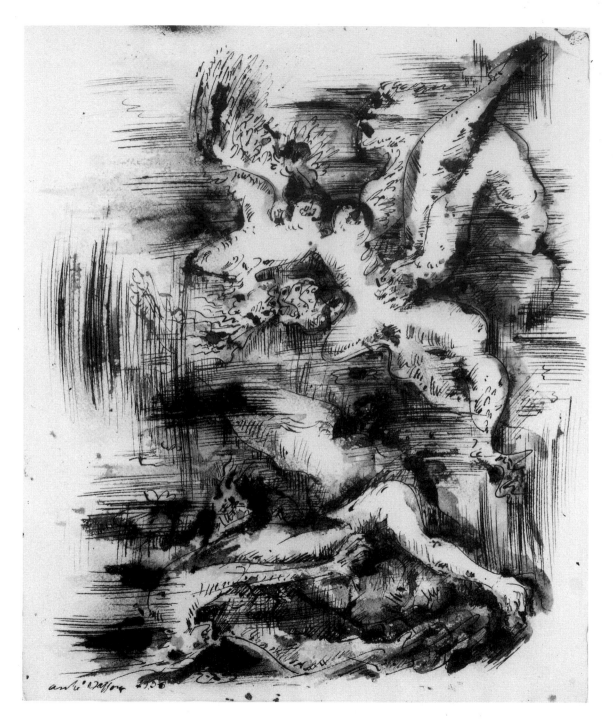

PLATE 33 · 52

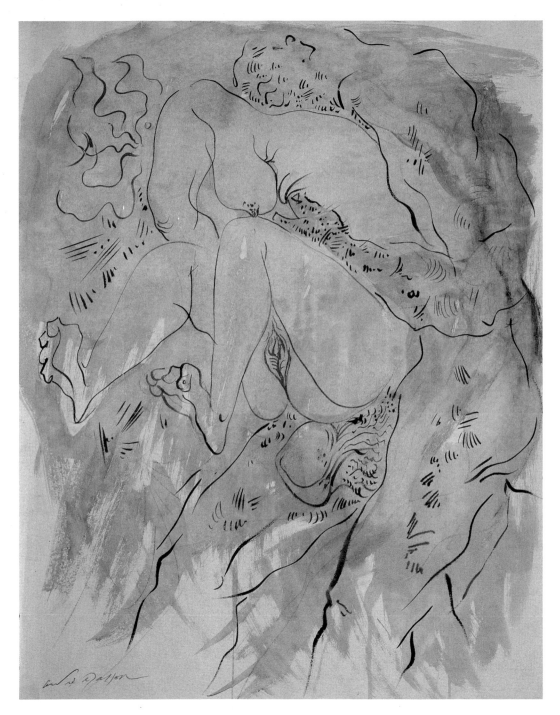

PLATE 34 · *135*

CATALOGUE NOTE

Titles given by the artist are shown in italic type.

Dates attributed to the works are in many cases tentative. A date on the drawing in the artist's hand has not necessarily been taken as conclusive.

Measurements are in centimetres, height first.

Where no lender is named the work has been lent by the artist or his family. The *Musée National d' Art Moderne, Centre Georges Pompidou, Paris,* has been abbreviated to *Musée National d' Art Moderne.*

List of works

1 Woman 1921/22
Pen and wash
17 x 24.4 cm

2 Women 1921/22
Pen and watercolour
18 x 22 cm
Signed
Galerie Louise Leiris, Paris
Plate 1

3 Women 1921/22
Pen and watercolour
32.5 x 28 cm
Signed
Plate 2

4 Woman 1921/22
Pen and watercolour
40.5 x 31 cm
Signed

5 Gambler 1922/23
Charcoal
31.5 x 22 cm
Signed
Musée National d'Art Moderne
Gift of Louise and Michel Leiris

6 Woodland 1922/23
Black and coloured crayons
51.7 x 40.8 cm
Signed
Musée National d'Art Moderne

7 Pomegranates 1922/23
Coloured crayon
38 x 44 cm
Signed
Galerie Louise Leiris, Paris

8 The post card 1923/24
Coloured crayon
59 x 46 cm
Signed
Galerie Louise Leiris, Paris

9 Little bones 1923/24
Pastel and sanguine
44.5 x 63.1 cm
Signed
Musée National d'Art Moderne

10 *Le dessin* 1923/24
The art of drawing
Pastel
48 x 63 cm
Signed
Musée National d'Art Moderne
Plate 7

11 Automatic drawing 1924/25
Pen
24 x 32 cm
Collection Maurice Jardot
Plate 10

12 Automatic drawing 1924/25
Pen
23.7 x 16 cm

13 Automatic drawing 1924/25
Pen
43 x 31 cm
Signed with monogram
Galerie Louise Leiris, Paris

14 Composition 1924/25
Inkwash
63 x 48 cm
Signed
Galerie Louise Leiris, Paris
Plate 8

15 Automatic portrait of
Michel Leiris 1925
Pen
31.8 x 24 cm
Signed and inscribed
Musée National d'Art Moderne
Gift of Louise and Michel Leiris

16 Automatic drawing 1925/26
Pen
42 x 32 cm
Signed
Collection Maurice Jardot

17 Automatic drawing 1925/26
Pen
42 x 32 cm
Signed
Collection Maurice Jardot

18 Automatic drawing 1925/26
Pen
30.3 x 24.1 cm
Signed and dated
Musée National d'Art Moderne
Plate 12

19 Automatic drawing 1925/26
Pen
41 x 29 cm
Signed and dated
Plate 11

20 Automatic drawing 1925/26
Pen
30 x 40 cm
Signed and dated

21 Automatic drawing 1925/26
Pen and wash
29.5 x 23 cm
Signed

22 Automatic drawing 1925/26
Pen and watercolour
37 x 29.5 cm
Signed

23 Pomegranates ?c1926
Pencil
37 x 52.5 cm
Signed
Galerie Louise Leiris, Paris

24 Composition 1926
Pastel
63.1 x 48.5 cm
Signed
Musée National d'Art Moderne

25 Composition 1926/27
Pen
63 x 48 cm
Galerie Louis Leiris, Paris

26 Automatic drawing 1927
Pen
43 x 31 cm
Signed with monogram
Galerie Louise Leiris, Paris

27 Automatic drawing 1927
Pen and sepia ink wash
43.2 x 31.3 cm
Signed with monogram
Musée National d'Art Moderne

28 Composition 1927
Pen and watercolour
43 x 31 cm
Signed with monogram
Galerie Louise Leiris, Paris
Plate 9

29 Figure 1927/28
Pen
63 x 48 cm
Signed
Galerie Louise Leiris, Paris

30 *Justine: Rodin et ses pensionnaires* 1928
Pen
43.8 x 33 cm
Signed and inscribed with title
Plate 5

31 Drawing for *Justine* 1928
Collage of tissue paper with watercolour,
pencil and pen
38.7 x 30.6 cm
Musée National d'Art Moderne

Two of the drawings made in the spring
of 1928 for an edition of Sade's *Justine*.
The project was dropped but the same
year Masson made illustrations for two
other erotic books which were published:
etchings for *Le con d'Irène* by Aragon and
lithographs for *L'histoire de l'oeil* by
Georges Bataille.

32 *Animal pris au piège* 1928/29
Animal caught in a trap
Pen and ink wash
32.8 x 32.6 cm
Signed and inscribed with title
Plate 13

33 Study for a mural decoration 1929
Pastel
22.5 x 55.5 cm

Commission carried out for Pierre-David
Weill in 1929

34 Composition with figures 1930/31
Pen and watercolour
40 x 31 cm

35 Falling figures 1931
 Pen
 41.2 x 32.5 cm
 Signed

36 Falling figures 1931
 Pen
 48.5 x 38 cm
 Signed with initials

37 Massacre c1931/32
 Pen
 42.6 x 59.3 cm
 Musée National d'Art Moderne

38 Massacre c1931/32
 Pen
 37.2 x 46.5 cm
 Musée National d'Art Moderne

39 Massacre 1933
 Pen
 40.5 x 53 cm
 Signed and dated
 Galerie Louise Leiris, Paris
 Plate 4

40 Massacre 1933
 Pen
 31.5 x 40.5 cm

41 Massacre 1933
 Pen
 35 x 45 cm
 Signed and dated

42 Massacre 1933
 Pen
 38.2 x 56 cm
 Signed
 Galerie Louise Leiris, Paris

43 Massacre 1933
 Pen
 30.5 x 45 cm
 Signed and dated
 Plate 3

44 Massacre 1933
 Pen
 25 x 32.5 cm
 Galerie Louise Leiris, Paris

45 Costa Brava 1934
 Pen and coloured chalks
 32 x 43 cm
 Signed with monogram
 Galerie Louise Leiris, Paris

46 Tossa de Mar 1934
 Pencil
 56.3 x 46.5 cm
 Signed

47 Spain 1934
 Pencil
 47 x 61 cm
 Signed
 Plate 21

48 Monserrat 1934
 Pencil
 47 x 63.2 cm
 Signed and dated *Décembre 1934*
 Plate 22

49 *Chardons* c1935
 Thistles
 Pen
 24.4 x 17.2 cm
 Inscribed with title

50 *Cul du coq se fermant (il meurt)* c1935
 Pen and gouache
 21 x 24.9 cm
 Inscribed with title

51 Night in Toledo 1936
 Watercolour
 49 x 63.5 cm
 Signed

52 Composition 1936
 Pen
 48 x 40 cm
 Signed and dated
 Plate 33

53 Figure 1937
 Pen
 48 x 31.5 cm
 Signed with initials and dated

54 Landscape with figures 1937
 Pen
 32 x 38.5 cm
 Signed and dated
 Galerie Louise Leiris, Paris

55 *Terre érotique* 1937
 Erotic land
 Pen and gouache
 50.5 x 65.5 cm
 Signed with initials, dated *20 Déc. 1937*
 and inscribed with title
 Plate 30

56 Poussinesque bacchanal ?1937
 Pen and watercolour
 21 x 31.5 cm
 Signed
 Collection Ivana de Gavardie

57 Erotic land c1938
 Pen
 39 x 28.5 cm
 Galerie Louise Leiris, Paris

58 Erotic land c1938
 Pen
 39 x 28.5 cm
 Signed

59 Erotic land c1938
 Pen
 44.5 x 34 cm

60 *Terre érotique* c1938
Erotic land
Pen
55.5 x 48 cm
Signed with initials and inscribed with
title
Collection Ivana de Gavardie
Plate 27

61 Sketchbook page 1938
Pen
62.5 x 47 cm
Signed, dated *5 Mai 1938* and inscribed

62 *Le cygne* 1938
The swan
Pen
36 x 50 cm
Signed, dated and inscribed with title

63 Winged figure c1938
Pen
64 x 50 cm
Signed

64 Head c1938
Pen
48.5 x 60 cm
Signed

65 Mythological composition 1938
Pen and wash
31.5 x 27.5 cm

66 Sketchbook page 1938/39
Pen
63 x 48 cm
Signed and inscribed
Plate 15

67 Studies for a painting c1939
Pen
49.5 x 58.5 cm
Galerie Louise Leiris, Paris

68 *Formes logiques* 1938
Logical forms
Pen
50 x 65 cm
Signed

This drawing and cat. nos 69, 71, 77 and
78 were published in *Anatomy of my
Universe,* New York, 1943.

69 *Le génie de l'espèce III* c1939
The genius of the species III
Pen
65 x 49.5 cm
Signed

70 Study for *Métamorphose* 1939
Pen and watercolour
43.2 x 24.2 cm

71 *Swift et Stella* 1939
Pen
48 x 63 cm
Signed with initials and dated
Plate 16

72 Two couples 1939
Pen
50 x 65 cm
Signed
Galerie Louise Leiris, Paris
Plate 17

73 City of the skull 1939
Pen
62 x 47 cm

74 Erotic land ?1939
Pen
31.5 x 49 cm
Edward Totah Gallery, London
Plate 28

74a Erotic land ?1939
Pen
24 x 31.5 cm
Signed

75 The palace 1940
Coloured inks
60 x 47 cm
Signed and dated

76 Head of Euclid 1940
Pen and wash
63 x 48 cm
Signed and dated *Avril 1940*

77 *L'académie de dessin*
The art school 1940
Pen
48 x 63 cm
Signed and dated
Galerie Louise Leiris, Paris

78 *La révolte dans la cuisine*
Revolt in the kitchen 1940
Pen
48 x 63 cm
Signed and dated
Plate 18

79 Praying mantis 1940/41
Pen and wash
35 x 53.5 cm
Signed
Galerie Louise Leiris, Paris
Plate 19

80 Death 1941
Pen
49 x 64 cm
Signed, dated and inscribed *Marseilles*

There is a further, more developed, study
for *L'assassinat du double*, entitled *Mort*, in
the Musée National d'Art Moderne,
Paris.

81 Montredon 1941
Pencil
48 x 63 cm
Signed
Galerie Louise, Paris

82 Martinique 1941
Black ink and coloured crayon
32 x 24 cm
Plate 25

83 Martinique 1941
Black ink
48 x 63 cm
Signed, dated and inscribed *Martinique*
Plate 23

84 *Rapt* 1941, printed in 1958
Rape
Dry-point
66 x 50 cm
Galerie Louise Leiris, Paris

85 *Rêve d'un futur désert*
Dream of a future desert 1942
Etching and dry-point
48 x 63 cm
Signed

The drawing on which the etching is
based was done in 1938.

86 Portrait of Jolas 1942
Pencil
48.2 x 44 cm
Signed

87 Woman and bull 1942
Pen and ink wash
38 x 56 cm
Signed
Plate 29

88 *Il n'y a pas de monde achevé* 1942
Pastel
33 x 43.5 cm
Signed

89 *Les jardins d'Armide*
The gardens of Armide *c*1943
Pen and ink wash
45.3 x 56 cm
Signed and inscribed with title

90 Erotic land 1943
Black ink, coloured crayon and white
gouache
56.9 x 43.9 cm
Signed
Musée National d'Art Moderne
Illustrated on cover

91 Study for *La pythie* 1943
Pen
28 x 33 cm
Signed

92 *Actaeon* 1943
Pen and ink
70.5 x 57.5 cm
Signed
Collection J L Leloir, Paris

93 Maple in the storm 1943/44
Pen
76.5 x 56.8 cm
Signed
Musée National d'Art Moderne

94 Nude 1944
Pastel
61 x 46 cm

95 *Femme sauvage*
Figure 1945
Black ink
24 x 31.5 cm
Signed with initials. Dated on verso

96 Book illustration 1945
Black ink
25.8 x 32 cm

97 Book illustration 1945
Black ink
21 x 30 cm

98 Book illustration 1945
Black ink
28.5 x 24 cm
Signed
Galerie Louise Leiris, Paris

99 Book illustration 1945
Black ink
27.4 x 27.8 cm

100 On the theme of desire 1947
Pen
50 x 64.3 cm

This and the next three drawings are four of 22 large drawings made in two days and reproduced in a portfolio, *Sur le thème du désir*, published in 1961, with an introduction by Jean-Paul Sartre.

101 On the theme of desire 1947
Pen
62.8 x 48 cm
Plate 32

102 On the theme of desire 1947
Pen
62.8 x 48 cm
Signed and dated

103 *L'épave lyrique*
Lyrical wreck 1947
Pen and black ink
64 x 50 cm
Inscribed with title

104 Sleep *c*1948
Pen and ink
50.2 x 64.5 cm

105 Camargue 1949
Pencil
43.2 x 31.3 cm

106 Camargue 1949
Pen
45.5 x 36 cm

107 Waterfall 1949
Pencil
27 x 20.5 cm

108 Waterfall 1949
Pencil
26.8 x 20.5 cm

109 Waterfall 1949
Pencil
26.7 x 20.4 cm

110 Waterfall 1949
Pencil
30.3 x 42 cm

111 Waterfall 1949
Pencil
30.3 x 42 cm

112 Waterfall 1949
Pencil
42 x 30.3 cm
Plate 24

113 Waterfall 1949
Ink
48.5 x 63.5 cm
Signed
Galerie Louise Leiris, Paris

114 Olive trunk 1949
Ink
64 x 49 cm
Signed
Collection Huynh-Tan Sung

115 *Fontaine de Vaucluse* 1949/50
Black chalk
31.5 x 26 cm
Inscribed with title
Plate 26

116 *Les catacombes*
Catacombs 1950
Charcoal and black ink
48 x 63 cm

117 Bather 1950
Pastel
41.5 x 41.5 cm

118 Storm over the Mont St Victoire 1950
Pastel
47.5 x 62 cm

119 Evening in the valley of the Arc 1950
Pastel
54 x 41.5 cm
Signed

120 Stormy shore 1950
Black chalk
26 x 33.8 cm
Signed with initials and dated

121 Study for *Les pigeons sur le toit* 1951
Coloured chalks
31.7 x 40.7 cm
Inscribed with title

122 Studies of bird *c*1951
Pastel
62.7 x 48.5 cm
Signed

123 Crouching woman ?*c*1952
Pen and watercolour
41 x 53.5 cm

124 Page from a sketchbook ?*c*1953
Pencil
44.5 x 58.5 cm

This and no. 125 are drawings inspired
by Japanese erotic prints of which
Masson owns several, including some by
Utamaro.

125 Page from a sketchbook *c*1953
Pencil
44.2 x 58.5 cm
Plate 6

126 *Les lavandières* 1954
Washerwomen
Black pencil on grey paper heightened
with white
29.5 x 35.5 cm

127 Dolomites 1954
Watercolour and ink wash
38 x 56 cm
Signed with initials and dated
Galerie Louise Leiris, Paris

128 Centaur 1954
Black ink and wash
62.5 x 48 cm
Signed and dated

129 Bacchanal ?1955
Pen, ink and watercolour
33 x 50.2 cm
Signed

130 Pollen 1955
Watecolour
56 x 28.5 cm

131 Composition 1955
Sand on paper
50 x 65 cm
Dated

132 Composition 1955
Sand on paper
48 x 63 cm
Plate 14

133 The wild horseman *c*1956
Oil on paper
74 x 55.5 cm

135 Two figures ?c1960
Gouache and wash on buff paper
60.2 x 47.3 cm
Signed
Plate 34

136 *Luxure* 1962
Pencil and coloured chalk, pastel
21.5 x 36 cm
Signed and inscribed with title

137 Werewolf 1963
Watercolour and pen
12 x 14 cm
Signed
Collection Maurice Jardot

138 Landscape with figure *c*1965
Coloured chalks
32.7 x 25 cm
Signed

139 *Apulei: l'âne d'or*
Apulius: The golden ass 1965
Pen and black ink on blue paper
39.5 x 31.7 cm
Signed and inscribed with title

140 Samson captured 1966
Ink and coloured chalk
38.5 x 49.7 cm
Signed
Collection Maurice Jardot

141 *Study for La mère nature* *c*1968
Coloured inks and coloured crayon
34.8 x 26.8 cm

142 *Les jardins d'Armide* *c*1970
Pen and ink wash
45 x 58 cm
Signed and inscribed with title
Galerie Louise Leiris, Paris
Plate 31

143 *Homage à William Blake* 1970
Pen
65 x 50 cm
Signed and inscribed with title
Collection Maurice Jardot

144 Reclining figure *c*1971
Pen
50 x 70 cm
Signed
Galerie Louise Leiris, Paris
Plate 20